America THE Beautiful
NEW YORK CITY

DAN LIEBMAN

Photographs by AMBIENT IMAGES

FIREFLY BOOKS

A FIREFLY BOOK

Published by Firefly Books Ltd. 2010

First printing

Publisher Cataloging-in-Publication Data (U.S.)

 Liebman, Dan.
 New York City. / Dan Liebman ; Ambient Images [photography].
[] p. : col. photos. ; cm. America the Beautiful series.
Summary: Captioned photographs showcase the remarkable architecture, dynamic
neighborhoods and exciting attractions of New York City.
ISBN-13: 978-1-55407-592-8 ISBN-10: 1-55407-592-0
1. New York (N.Y.) – Pictorial works. 2. New York (N.Y.) – Buildings, structures, etc. –
Pictorial works. I. Ambient Images. II. America the Beautiful / Dan Liebman. III. Title.
974.7/1 dc22 F128.37L54 2010

Published in the United States by
Firefly Books (U.S.) Inc.
P.O. Box 1338, Ellicott Station
Buffalo, New York 14205

Published in Canada by
Firefly Books Ltd.
66 Leek Crescent
Richmond Hill, Ontario L4B 1H1

Cover and interior design: Kimberley Young

Printed in China

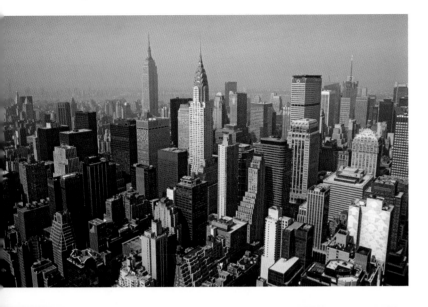

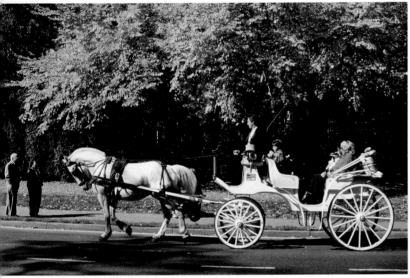

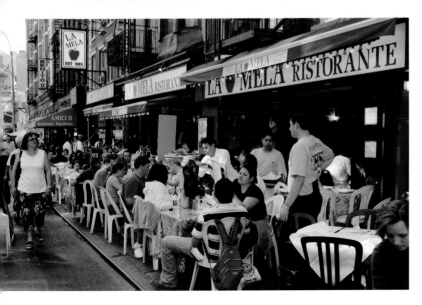

THE STATUE of Liberty, whose image graces the cover of this book, stands in the middle of the harbor of New York City. A symbol of freedom throughout the world, she has greeted millions of immigrants and visitors as they arrived here.

New York City has long been a port of entry for newcomers seeking a better life. Those new arrivals helped contribute to the richness of a place that has been called the entertainment capital of the world, the financial hub, the city that never sleeps, Gotham and, most famously, the Big Apple.

The city is rich in history. In 1524, Giovanni da Verrazzano sailed into New York's harbor. The first Dutch settlers established New Amsterdam at the foot of Manhattan Island a hundred years later. Renamed New York in 1664 after the Duke of York, the city became the first capital of the newly formed United States in 1788. Before long, New York emerged as the largest city and the economic center of the United States.

The 19th century saw the city transformed by immigration and development. The opening of the subway in the early 20th century helped bind the city together. In 1902 the Fuller Building – known as the Flatiron Building – became the first of many skyscrapers that would symbolize New York.

But more than buildings exemplify a great city. When terrorists attacked the Twin Towers on September 11, 2001, killing more than 2,700 people at the World Trade Center, New York City showed the world its determination to remain a great city. The destruction of the buildings changed the skyline, but not the spirit of New Yorkers.

In the pages that follow, we provide a sampling of the city – its landmarks, architectural gems, urban oases, cultural and sports institutions, neighborhoods, family attractions, flavors and people. We hope you'll enjoy your visit as you travel the pages of *America the Beautiful – New York City.*

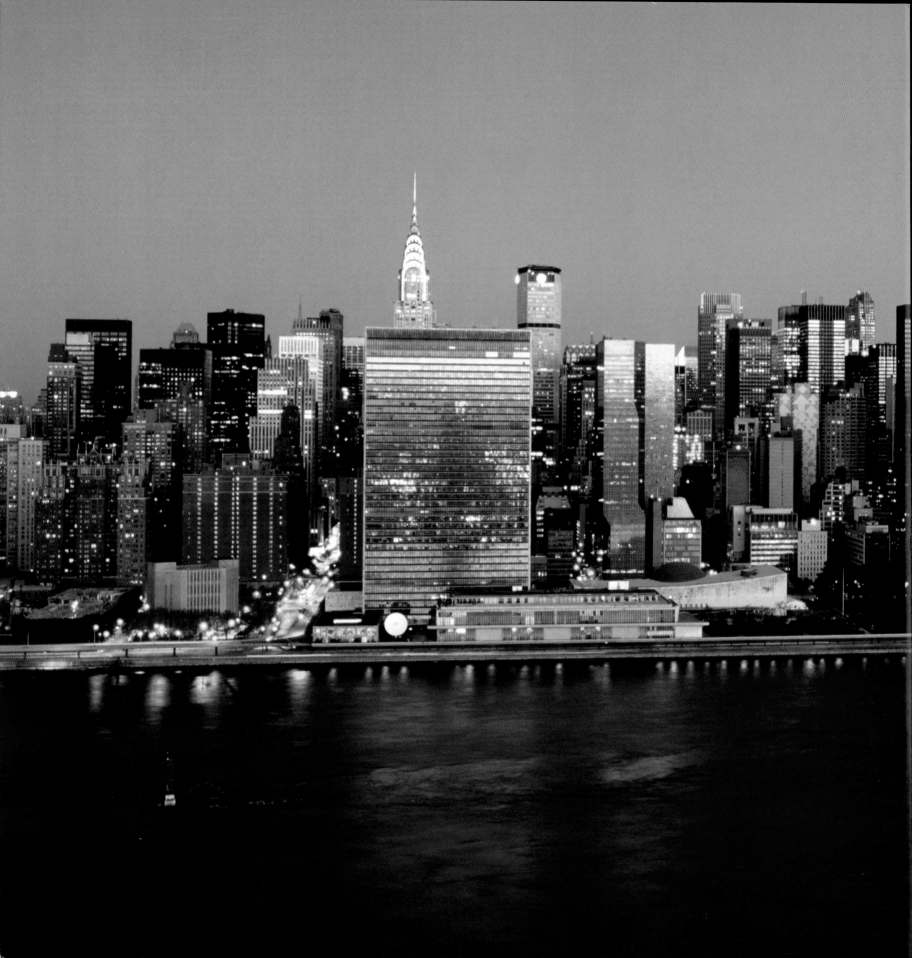

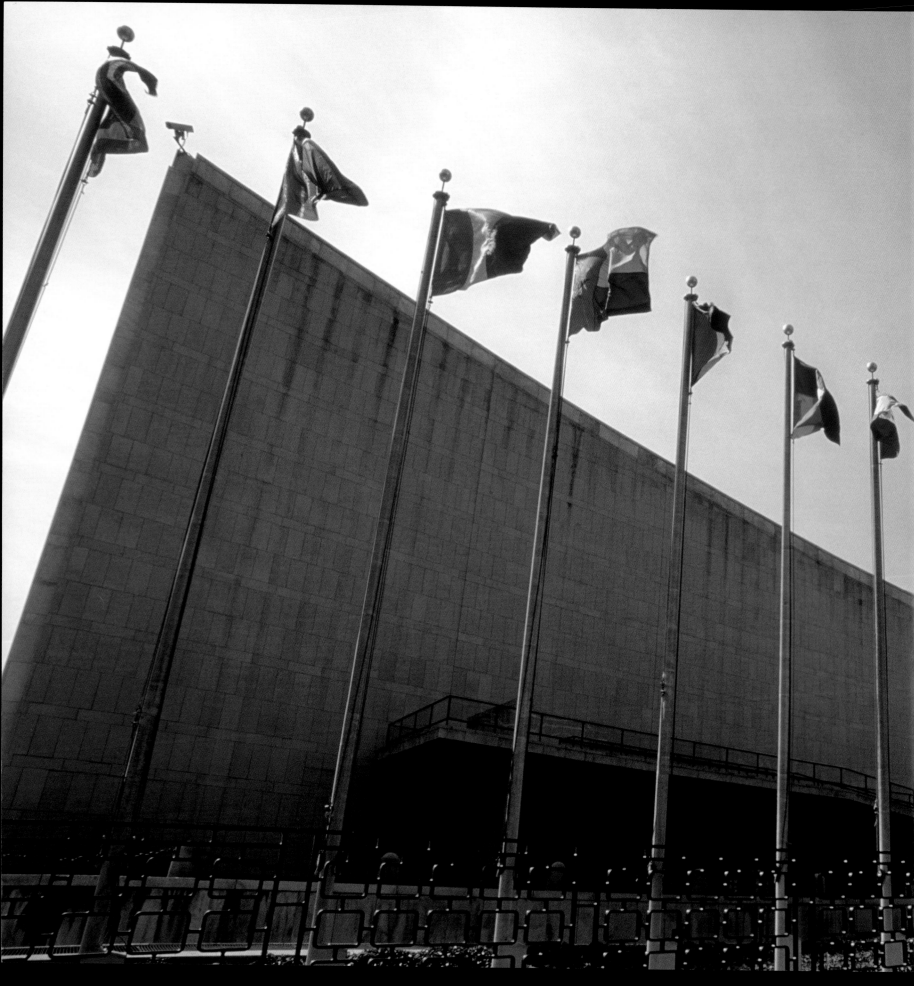

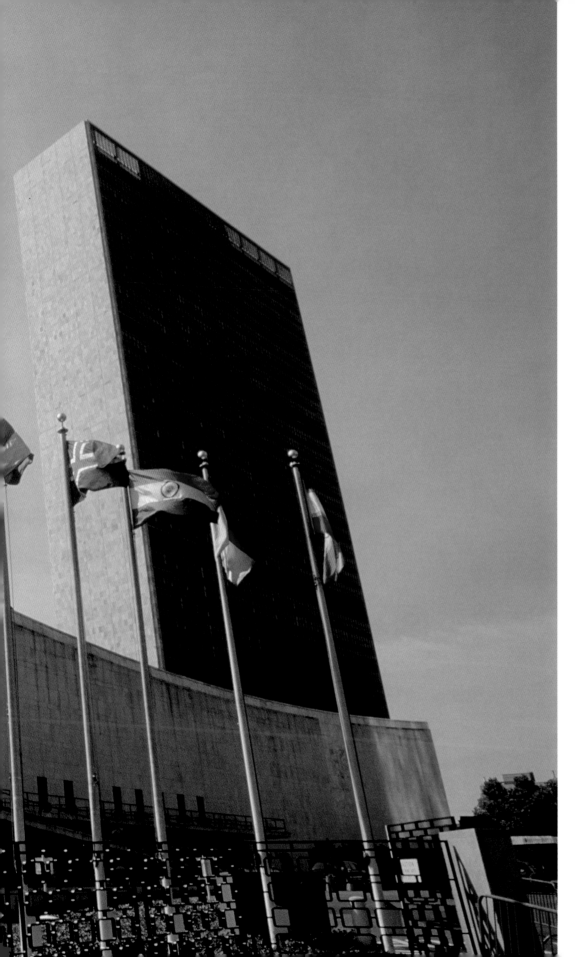

The United Nations was established in 1945, and nearly every sovereign state in the world is now a member. The UN is dedicated to maintaining international peace and promoting cooperation in solving international economic, social and humanitarian problems.

PREVIOUS PAGE: The midtown Manhattan skyline, with the East River in the foreground. The all-glass facade of the United Nations fronts the river, with the Chrysler Building towering behind it. On the right is the triangle-topped Citicorp Center.

The Statue of Liberty, with her torch raised dramatically upward, was presented as a gift from the French to the American people in 1866. It is a symbol of freedom and a testament to the city's resilience. In 2004, it opened for the first time following the September 11, 2001, terrorist attack on the World Trade Center. The statue's crown has seven rays on it, representing the seven continents and the seven seas.

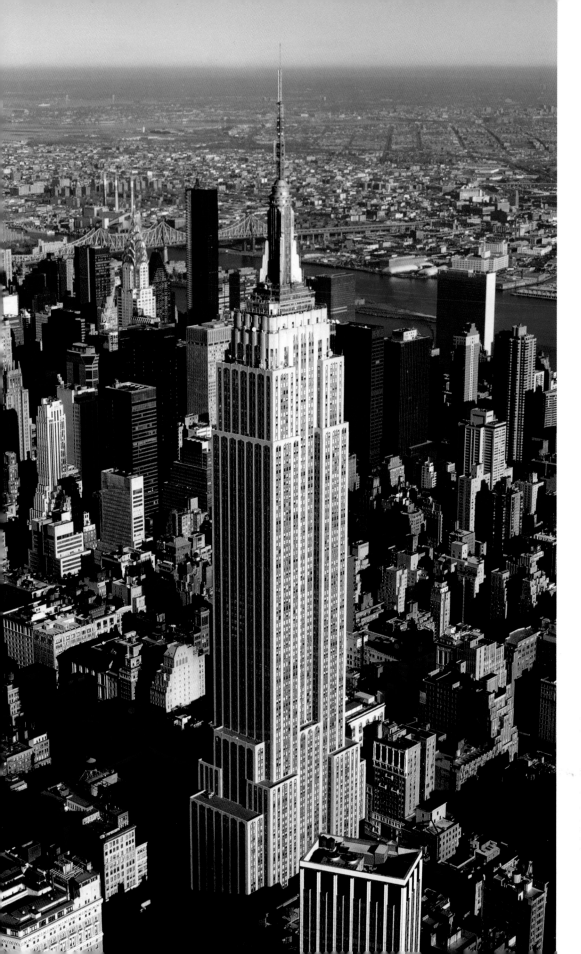

An aerial view of the Empire State Building, the tallest skyscraper in New York and a symbol of the city. Construction began in 1930, and the building was completed in 1931 – the first in the world to contain over one hundred floors. The Empire State Building rises 1,472 feet, with an observatory located on the 102nd floor.

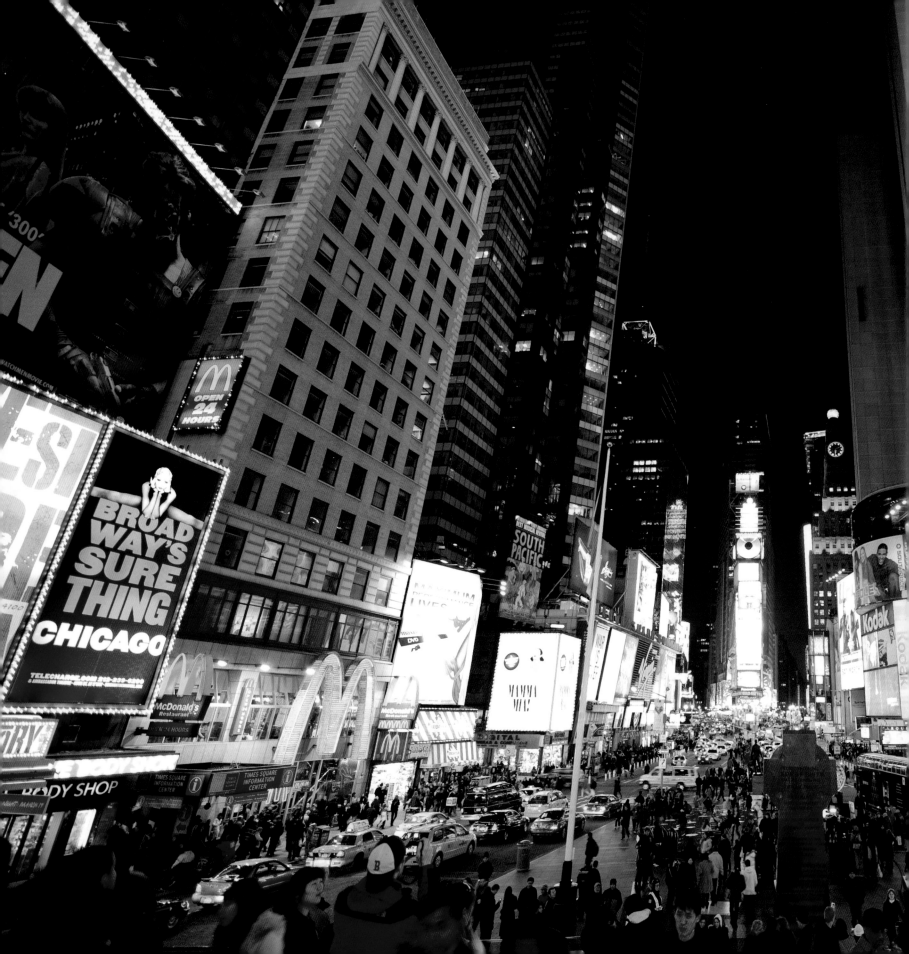

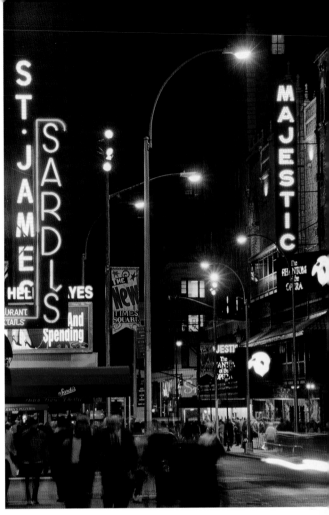

ABOVE: West 44th Street is in the heart of the Theater District. Sardi's restaurant is a theater hangout as well as a location for opening-night parties. It is well known for its collection of caricatures of show-business celebrities.

Times Square, synonymous with lights and crowds, is the most bustling square in New York. It's famous for Broadway theaters, movie houses and giant billboards. A magnet for tourists and a symbol of the city, the square has been dubbed the crossroads of the world.

The South Street Seaport in Lower Manhattan, adjacent to the Financial District, is a reminder of New York's historic role as a great port. Tall ships are moored here, and the area is popular for its shops and cafés. The South Street Seaport museum chronicles the story of New York's rich maritime past.

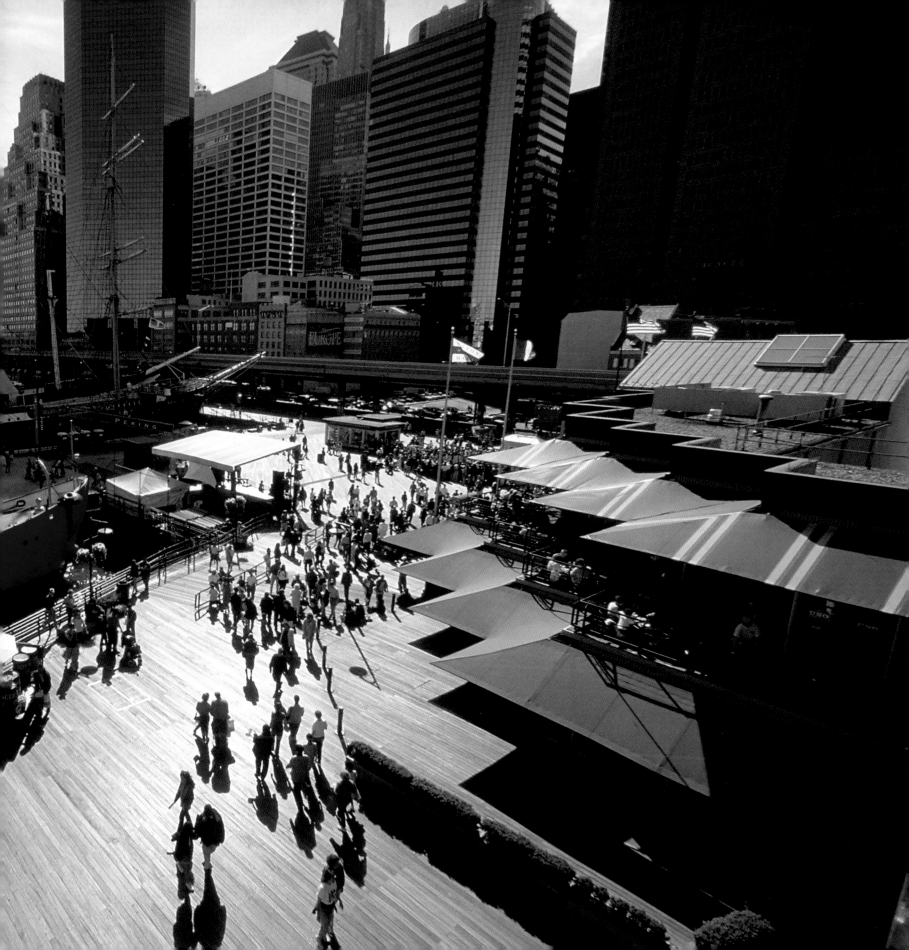

Millions of immigrants entered the country through the golden door of Ellis Island. Today, the Ellis Island Immigration Museum is part of the Statue of Liberty National Monument. A special feature of the museum is the Wall of Honor, which overlooks the Statue of Liberty and celebrates American immigration from its earliest beginnings to present times.

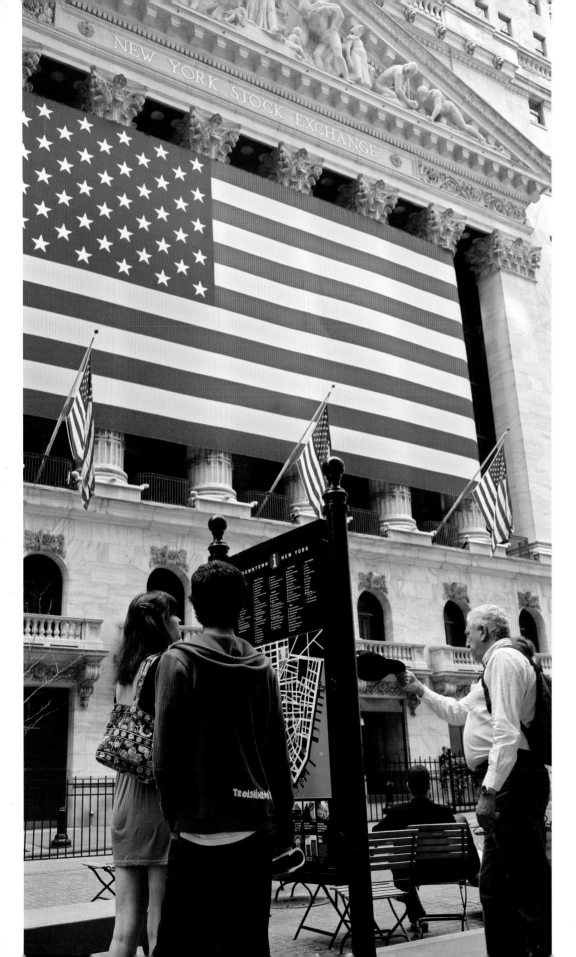

The New York Stock Exchange, the heart of the Financial District, is the largest stock exchange in the world. This marble-fronted building has been the home of America's principal securities market since 1903. Located on Broad Street between the corners of Wall Street and Exchange Place, the building has been designated a National Historic Landmark. The exchange itself can be traced back to 1792.

New York City was the first capital of the United States, and in 1789 George Washington was sworn in as president at Federal Hall. The original building was demolished in the 19th century and replaced by the current structure – the first United States Customs House – at Wall and Broad Streets.

OPPOSITE PAGE: General Grant National Memorial, popularly known as Grant's Tomb, is located in Riverside Park, overlooking the Hudson River, on Manhattan's Upper West Side. The mausoleum contains the bodies of Ulysses S. Grant – the American Civil War General and 18th president of the United States – and his wife, Julia Dent Grant.

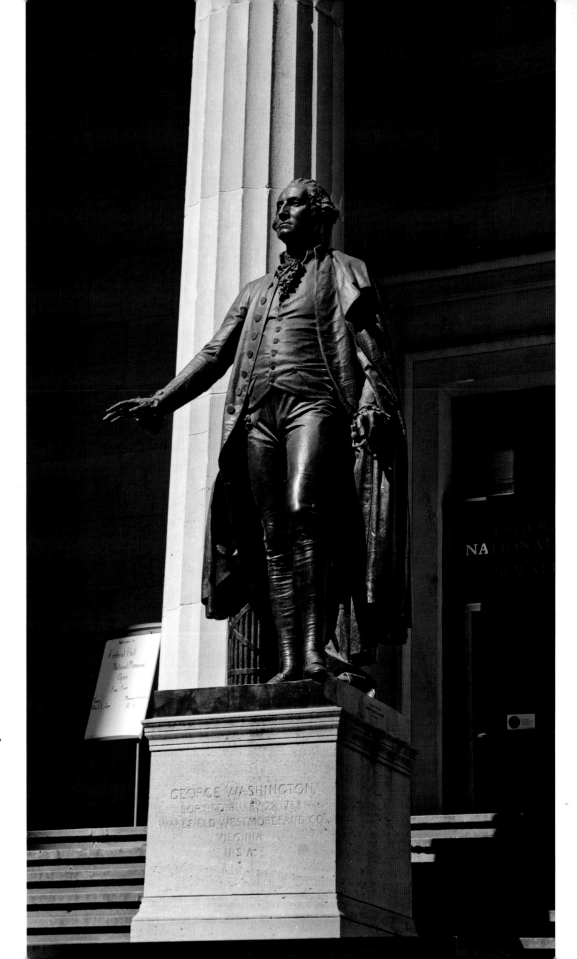

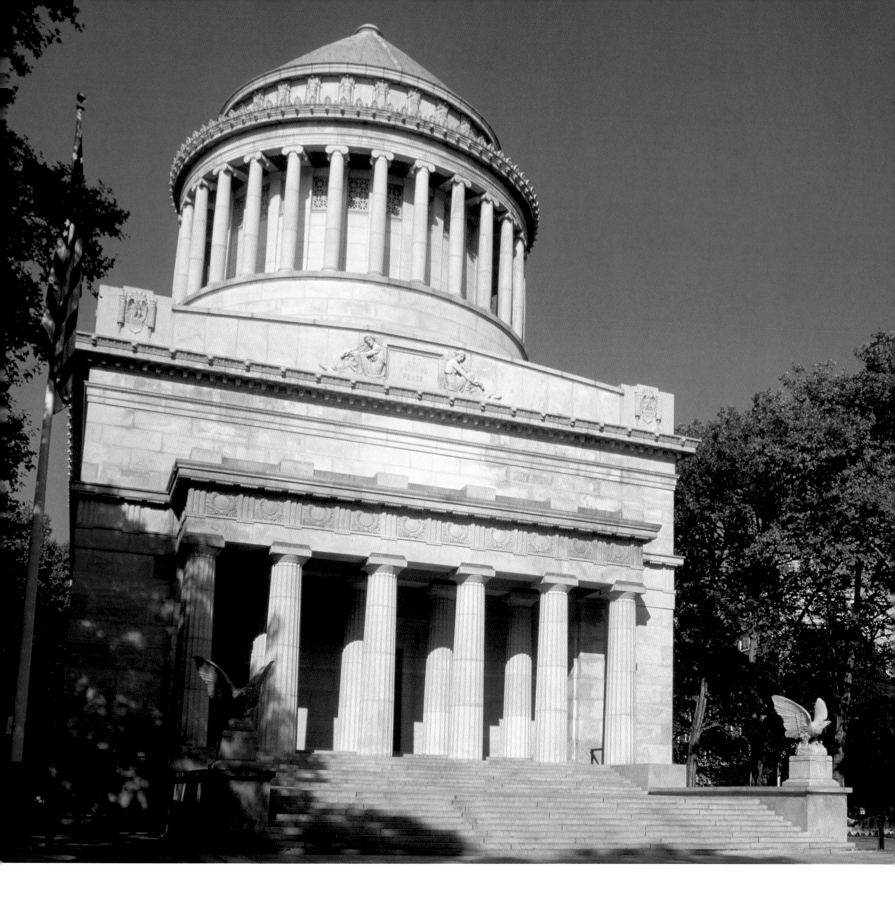

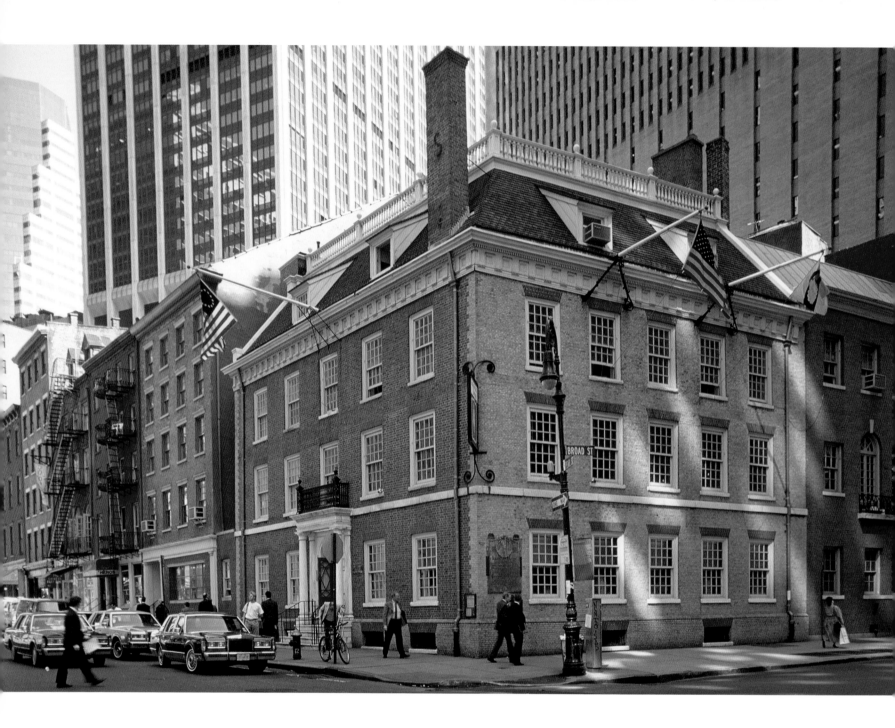

Fraunces Tavern in Lower Manhattan is a reconstruction of a building that figured prominently in early U.S. history. From the original tavern, General George Washington bade farewell to his officers before returning to Virginia. Now housing a museum and a restaurant, the tavern was made a New York City landmark and is listed on the National Register of Historic Places.

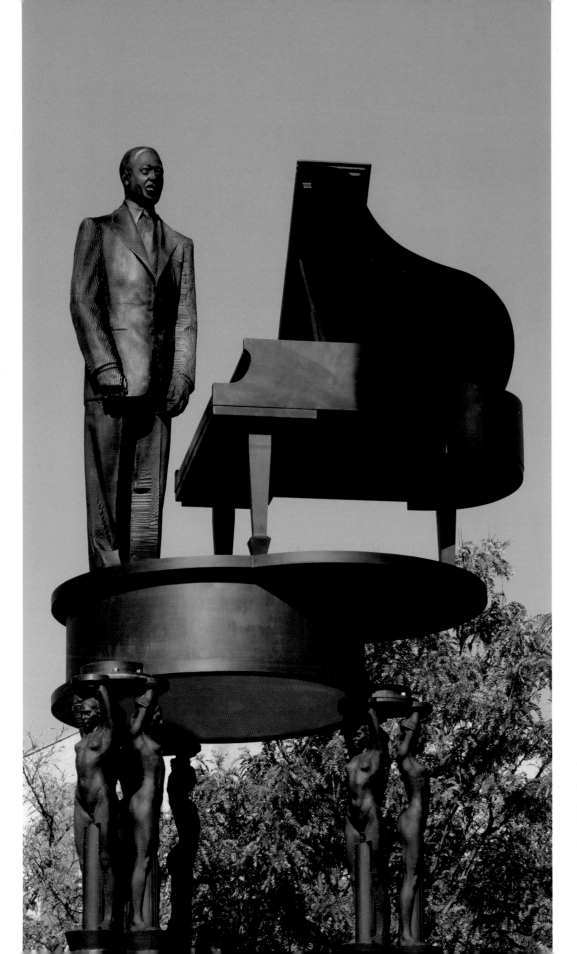

The Duke Ellington statue at 110th Street and Fifth Avenue honors the great American composer, pianist and jazz orchestra leader. The sculpture, by Robert Graham, was dedicated in 1997.

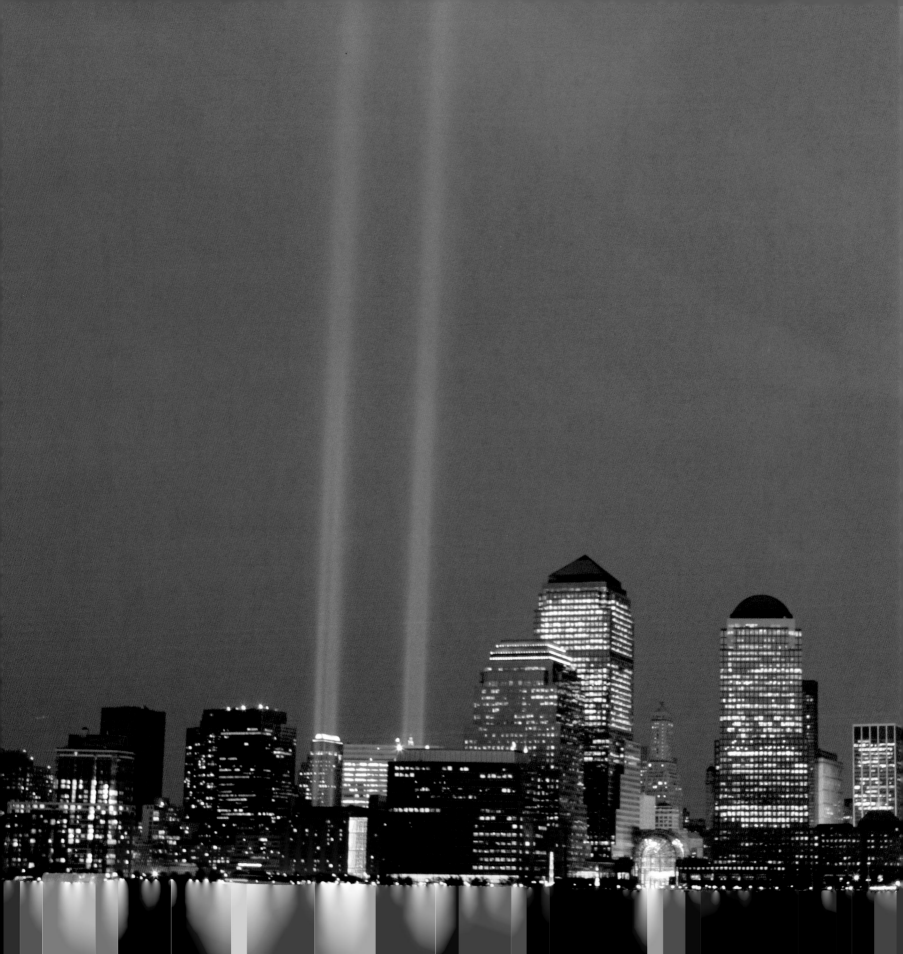

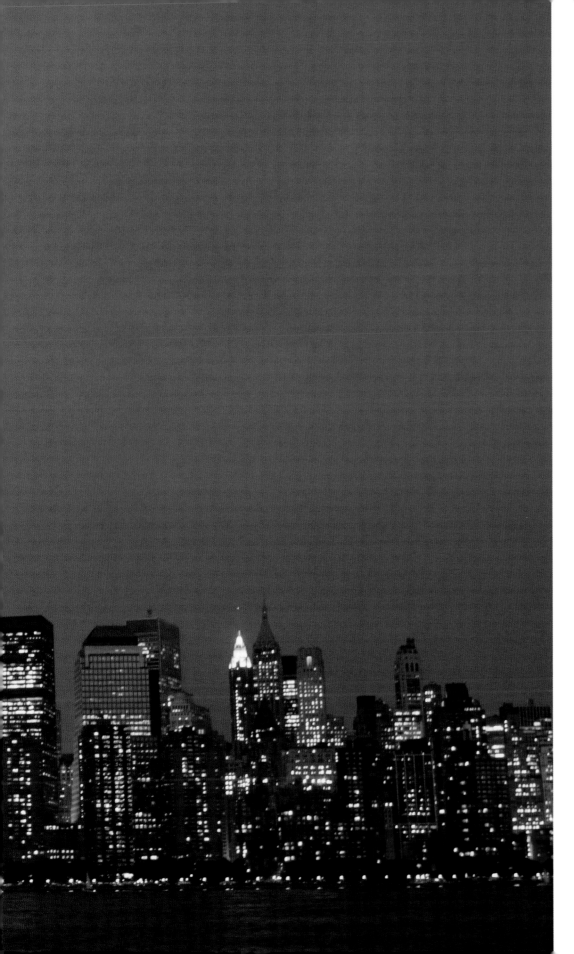

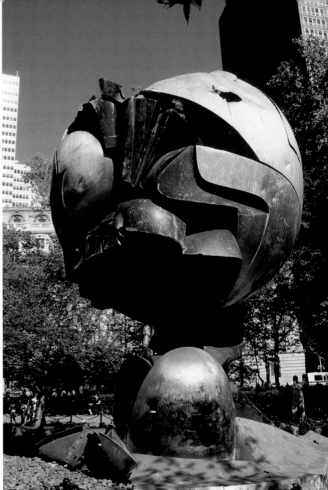

ABOVE: "The Sphere" is a bronze sculpture displayed in Battery Park. It originally stood between the World Trade Center towers and was recovered from the rubble of the buildings after the September 11, 2001, attacks. Six months later, it was relocated to Battery Park and rededicated as a memorial. The sculpture will eventually be returned to its original location.

The Tribute in Light was created next to the site of the World Trade Center to provide two columns of light in remembrance of the September 11, 2001, attacks. Initially a temporary installation, it has been repeated every year on the anniversary of the attacks.

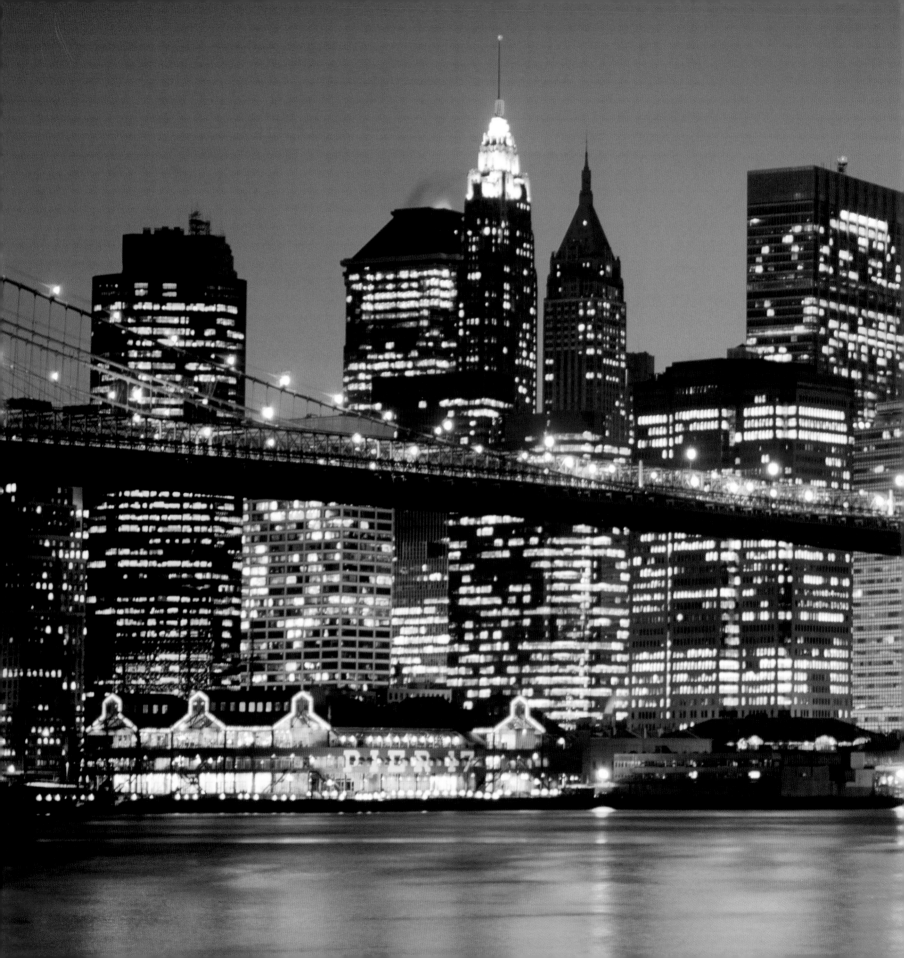

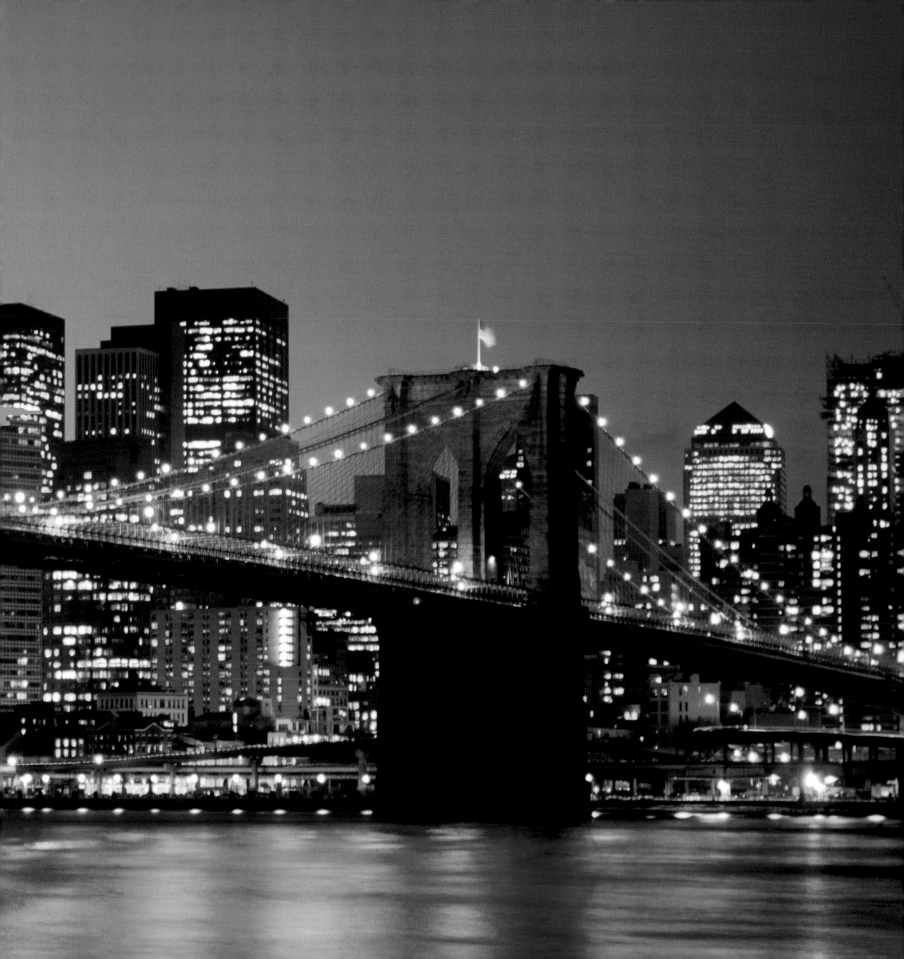

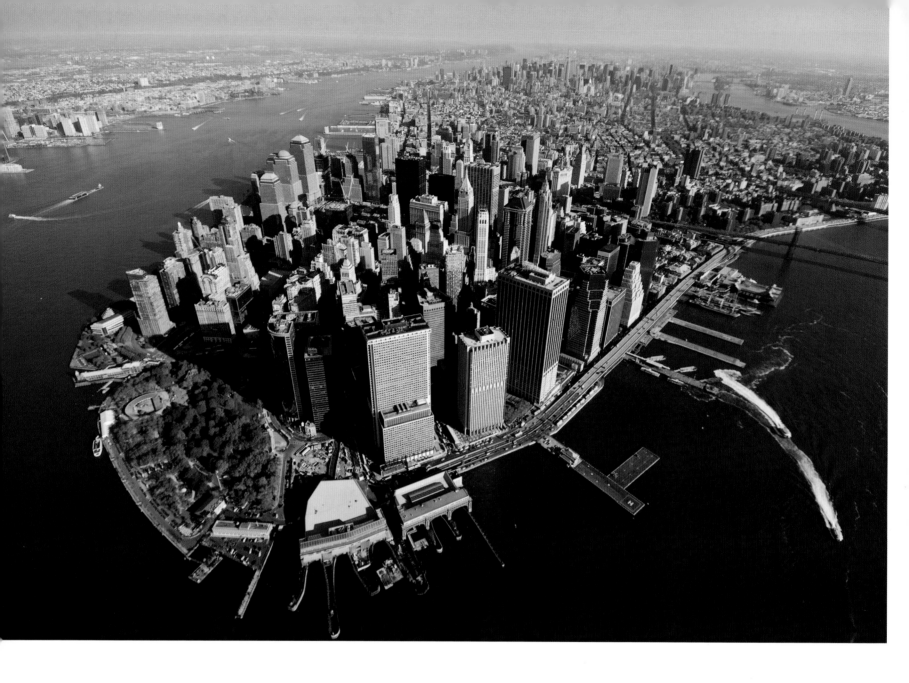

Being an island, Manhattan had to grow upward. Lower Manhattan is the third-largest business district in the country and home to a wide range of industries, including financial services.

PREVIOUS PAGE: The Brooklyn Bridge and the Lower Manhattan skyline at night. The bridge, which connects Manhattan with Brooklyn over the East River, is one of New York's most magnificent landmarks and a legendary feat of engineering. The South Street Seaport is illuminated on the left.

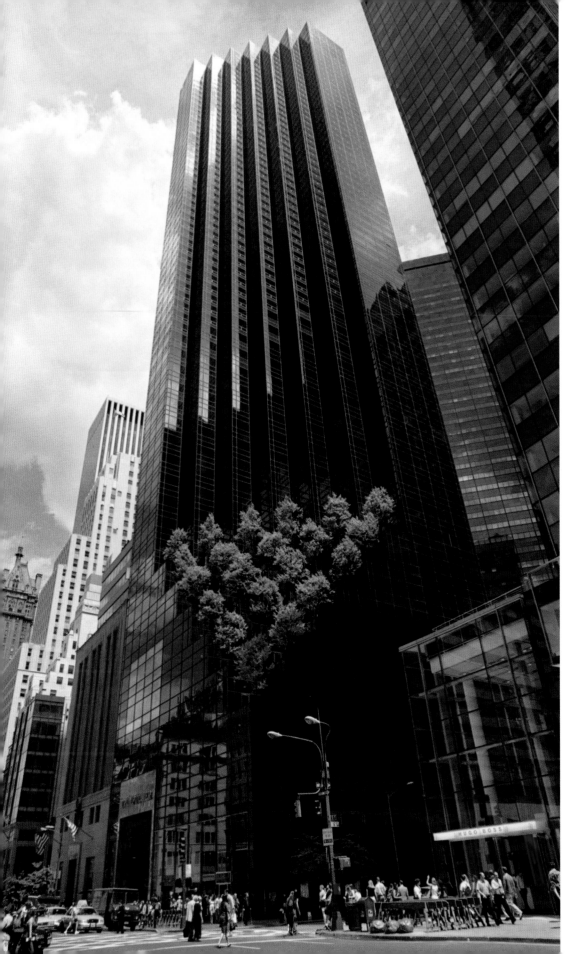

The Trump Tower, at the corner of Fifth Avenue and 56th Street, is perhaps best known as the setting of the television show, *The Apprentice*. The tower's public spaces include shops and cafés, and the glitzy building, which epitomizes the glamour of the city, is considered among New York's most desirable – and priciest – addresses.

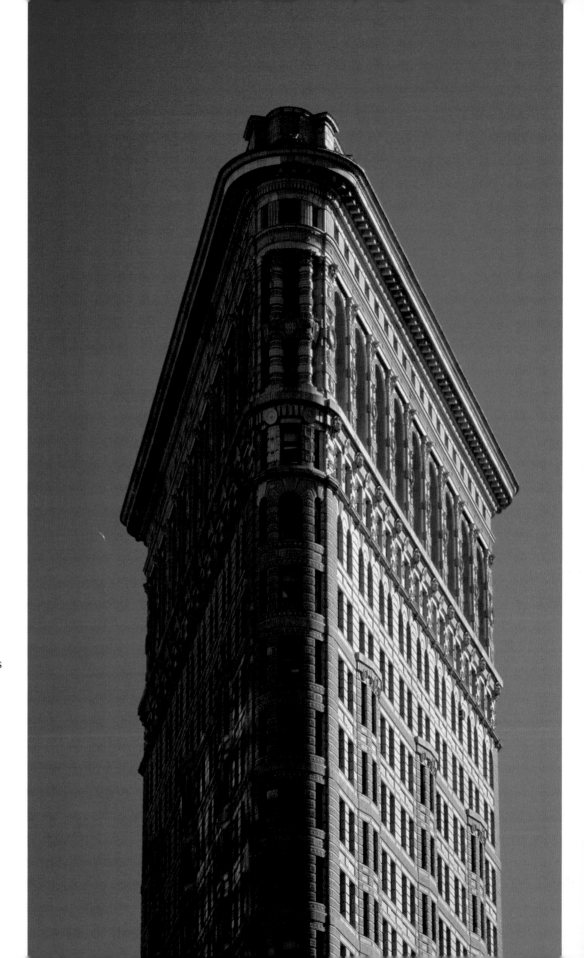

The Flatiron Building, originally called the Fuller Building, is one of the first skyscrapers ever built. It sits on a triangular island block where 23rd Street, Fifth Avenue and Broadway all meet.

OPPOSITE PAGE: A statue honoring Christopher Columbus graces Columbus Circle, the southwest entry to Central Park. Behind it is the Time Warner Center, consisting of two towers bridged by an atrium containing upscale shops.

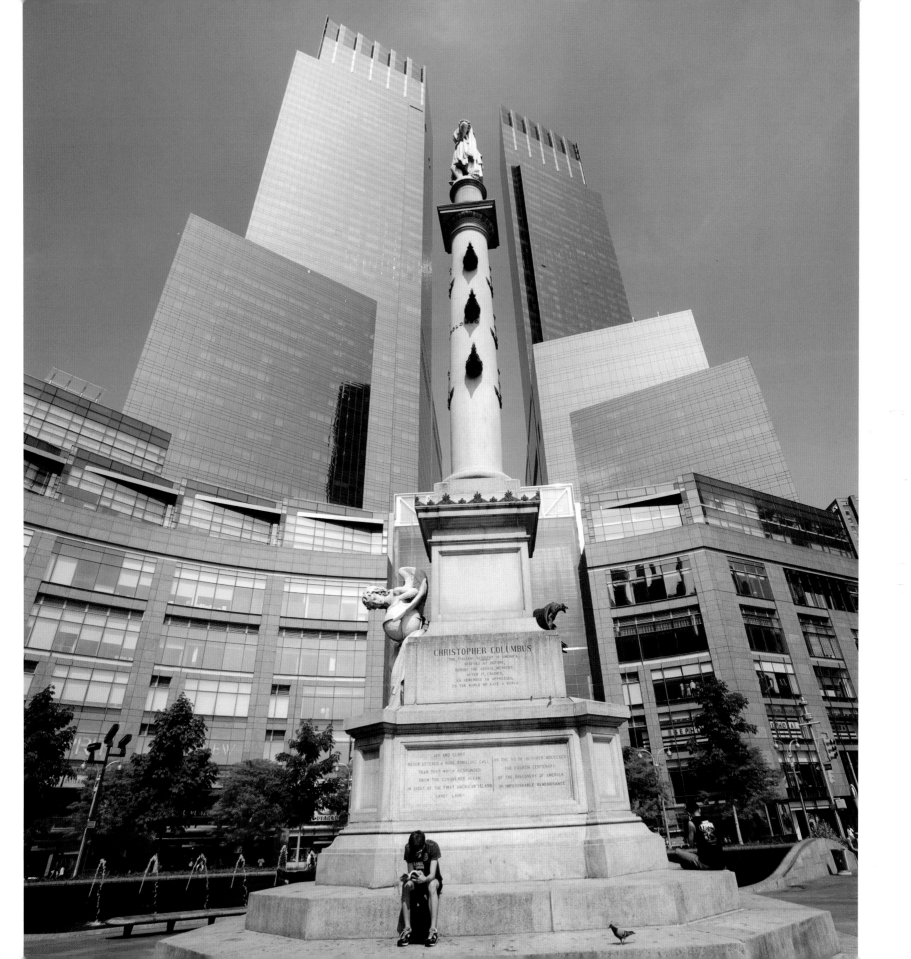

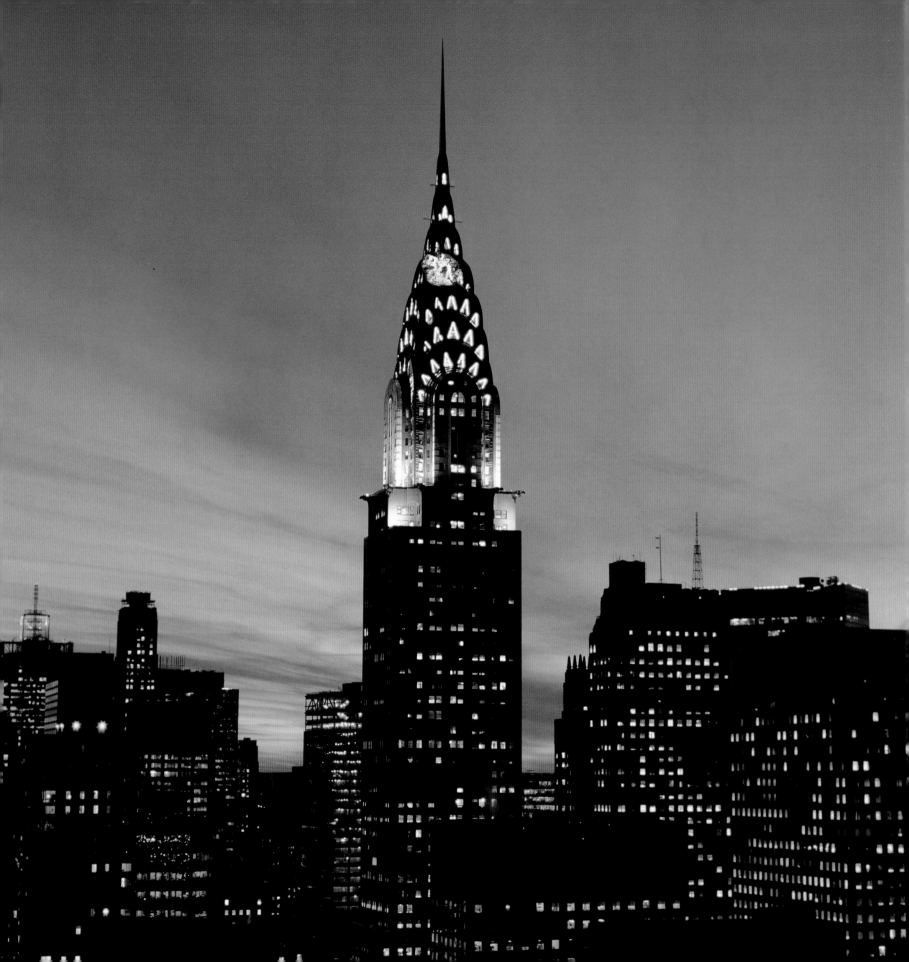

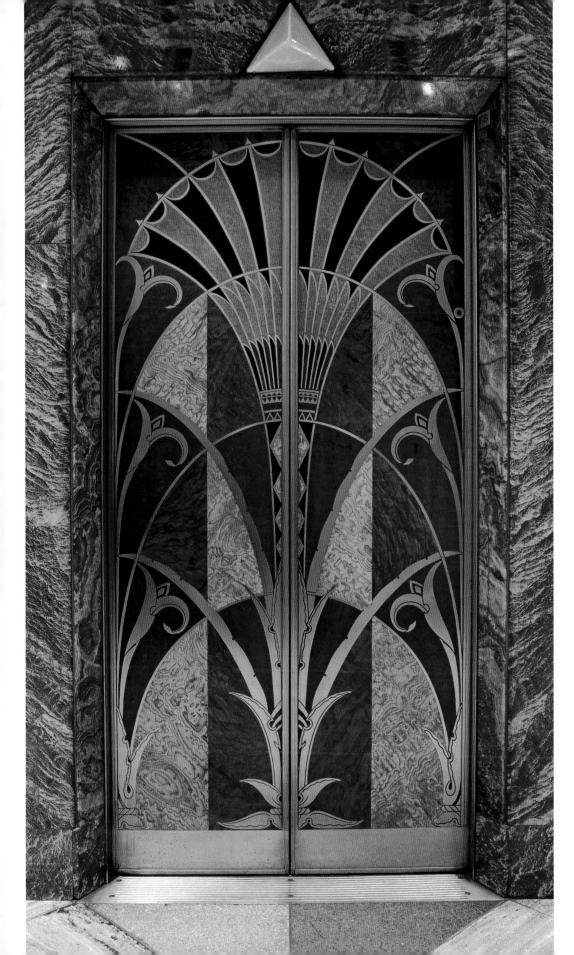

The Chrysler Building's Art Deco magnificence extends to the lobby and, especially, the dazzling elevator doors. All of the building's 32 elevators are lined in a different pattern of wooden paneling, and eight varieties of wood from all over the world were used in the elevator décor.

OPPOSITE PAGE: The 1930 Chrysler Building was the city's tallest skyscraper, at 1,046 feet – until, 13 months later, the Empire State Building gained the title. With its Art Deco design, ornamentation (which includes the 1928 Chrysler Eagle hood) and tapered top, it is considered by many to be New York's finest architectural gem.

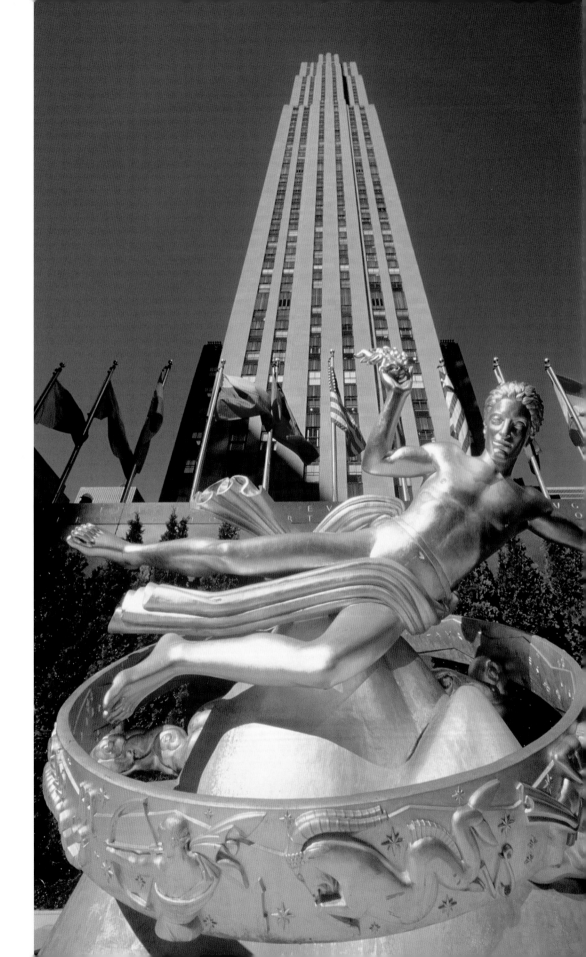

The statue in front of 30 Rockefeller Plaza ("30 Rock") depicts the Greek Titan Prometheus bringing fire to humankind. Rockefeller Center, a complex of 19 commercial buildings, was completed in 1939 and today is a National Historic Landmark.

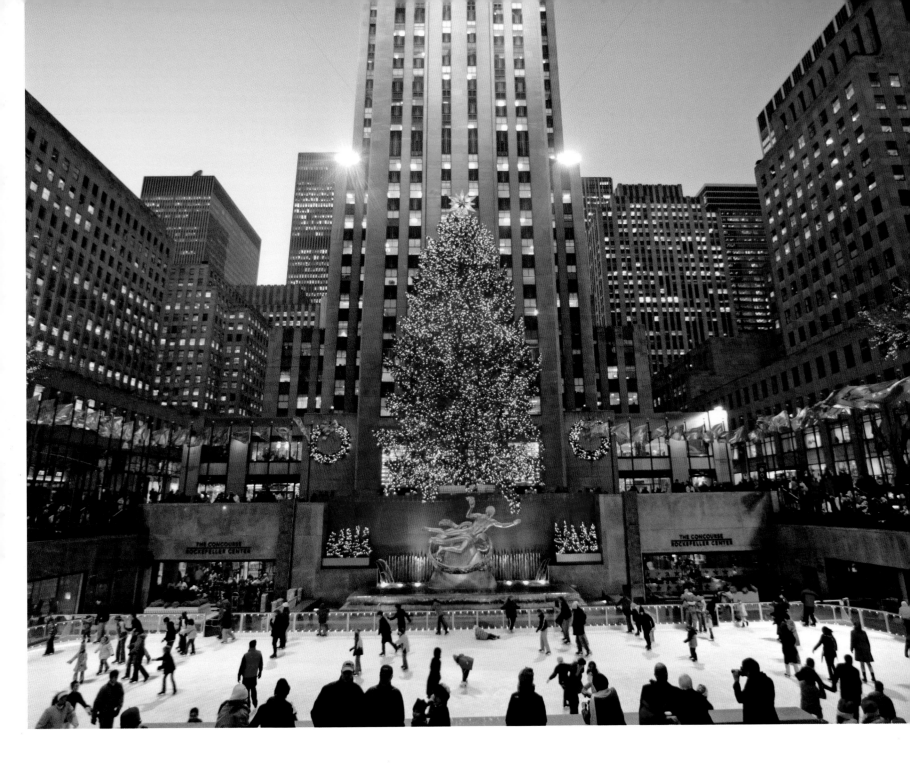

Skaters glide in front of the magnificently lit Christmas Tree at Rockefeller Center. The tree is a must-see attraction during the holiday season. It has been put up every year since 1931, when construction workers decorated a small tree with tin cans, strings of cranberries and paper garlands. In summer, the skating rink becomes a garden.

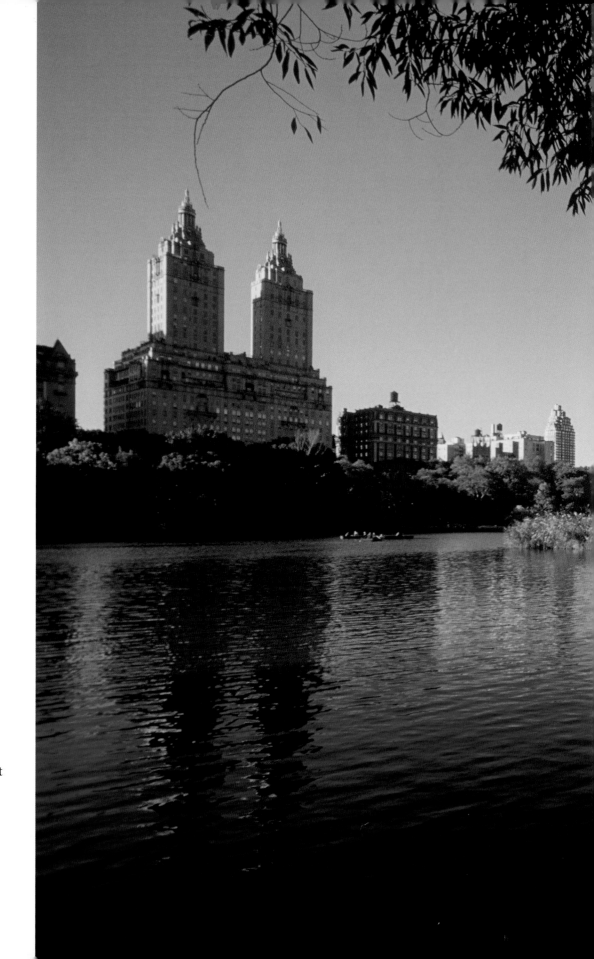

Central Park is New York City's backyard. It includes lakes, graceful bridges and arches, meadows and playgrounds. Reflected in the lake are the towers of the luxurious San Remo apartments on Central Park West.

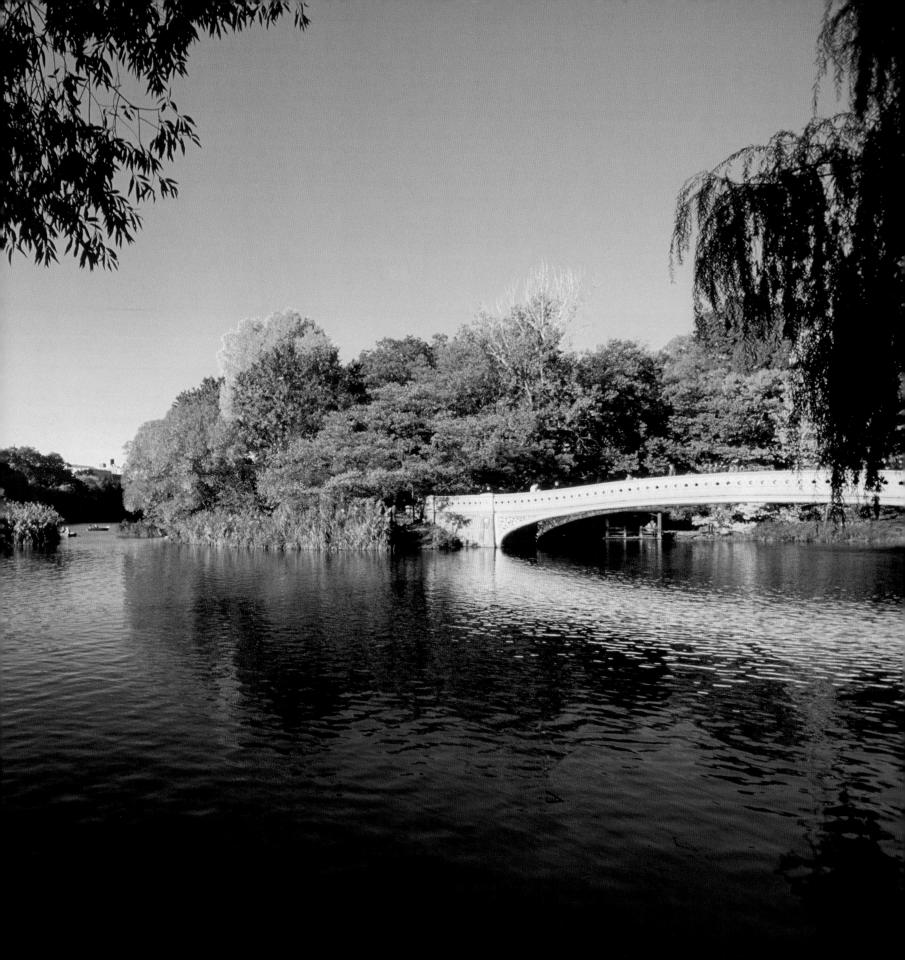

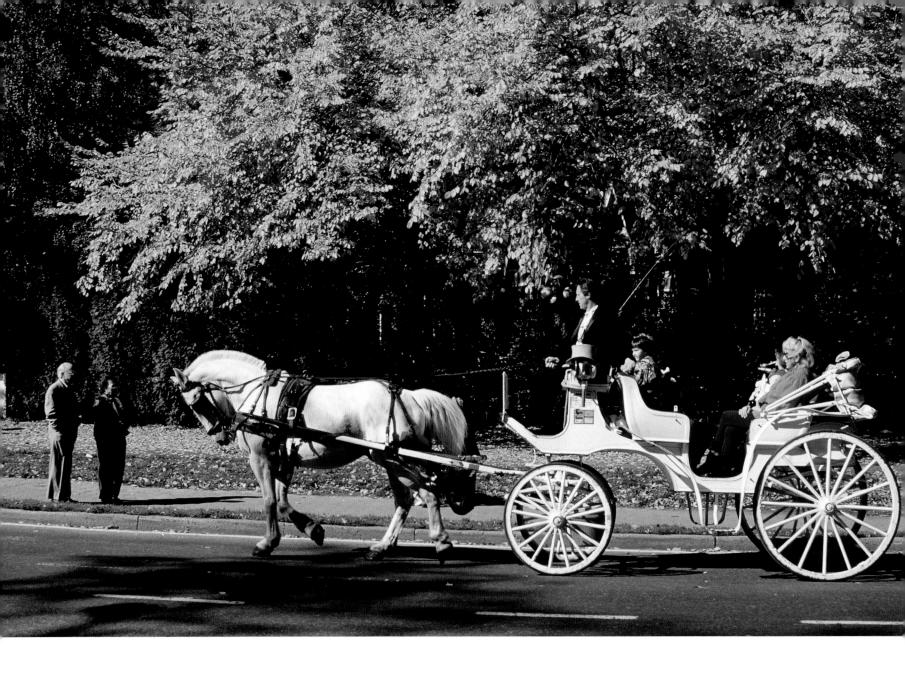

Horse-drawn carriage rides through Central Park provide family fun or a romantic evening.
The carriages, traditionally called "hansom cabs," operate year-round.

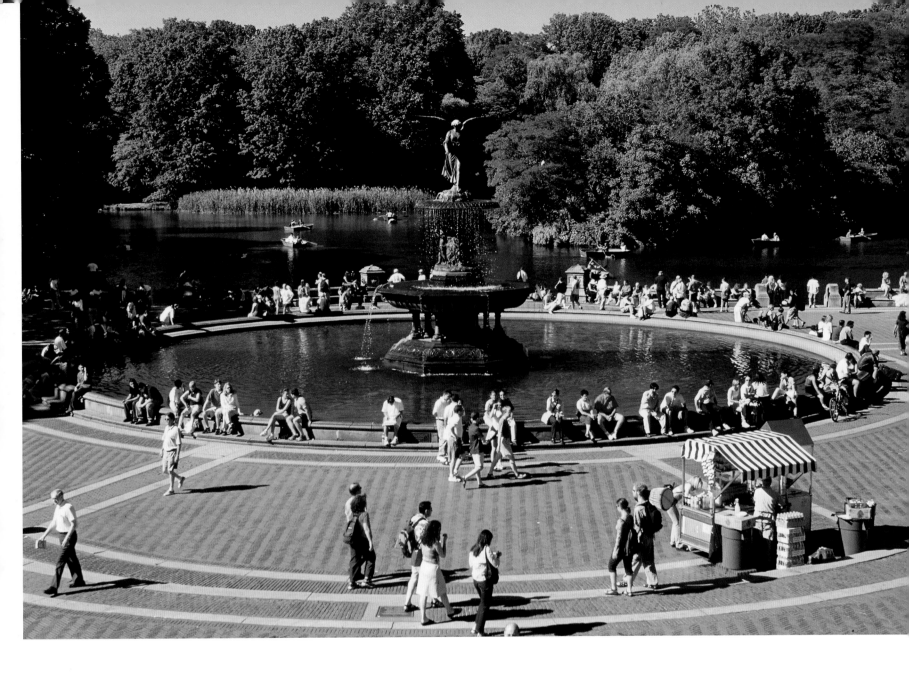

Bethesda Fountain is a favorite meeting place in Central Park. The sculpture that tops it is called "Angel of Waters." One of the most recognizable and photographed features of the park, the fountain has appeared in numerous movies.

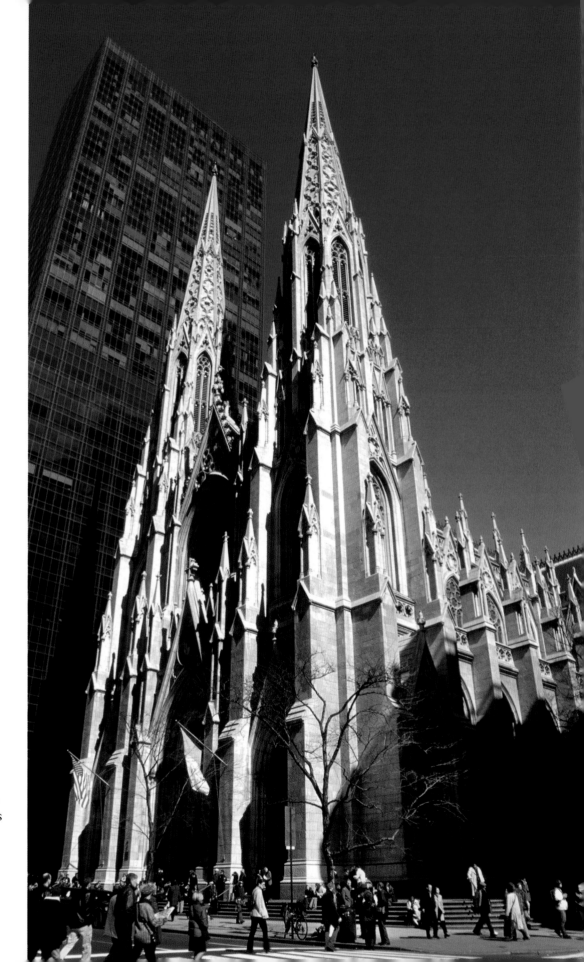

St. Patrick's Cathedral, the seat of the Archbishop of New York, is the largest decorated Gothic-style Catholic cathedral in the country. The Fifth Avenue cathedral seats about 2,200 people and greets three million visitors yearly.

The St. Patrick's Day Parade on Fifth Avenue is a New York City tradition. The parade is held to honor the patron saint of Ireland and is famous for displays of green face paint, green food coloring and green clothes. It dates back as far as 1766.

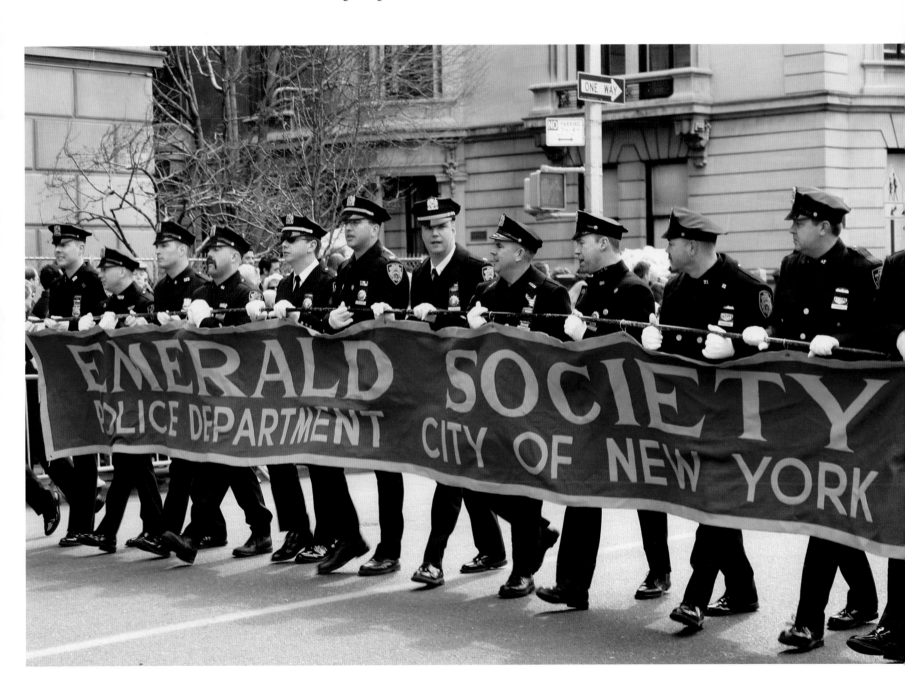

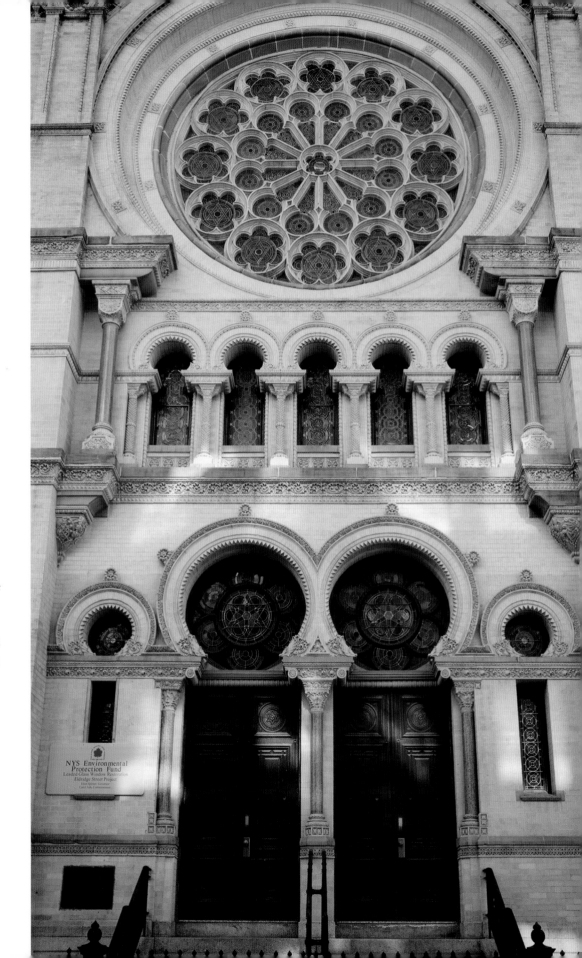

The Museum at Eldridge Street, based in the 1887 Eldridge Street Synagogue, presents the culture, history and traditions of the great wave of Jewish immigrants to the city's Lower East Side. The landmark building has been restored to its original grandeur.

OPPOSITE PAGE: Riverside Church – which describes itself as an interdenominational, interracial and international congregation – is modeled after the 13th-century Gothic cathedral in Chartres, France. It is situated at one of the highest points of New York, overlooking the Hudson River and 122nd Street.

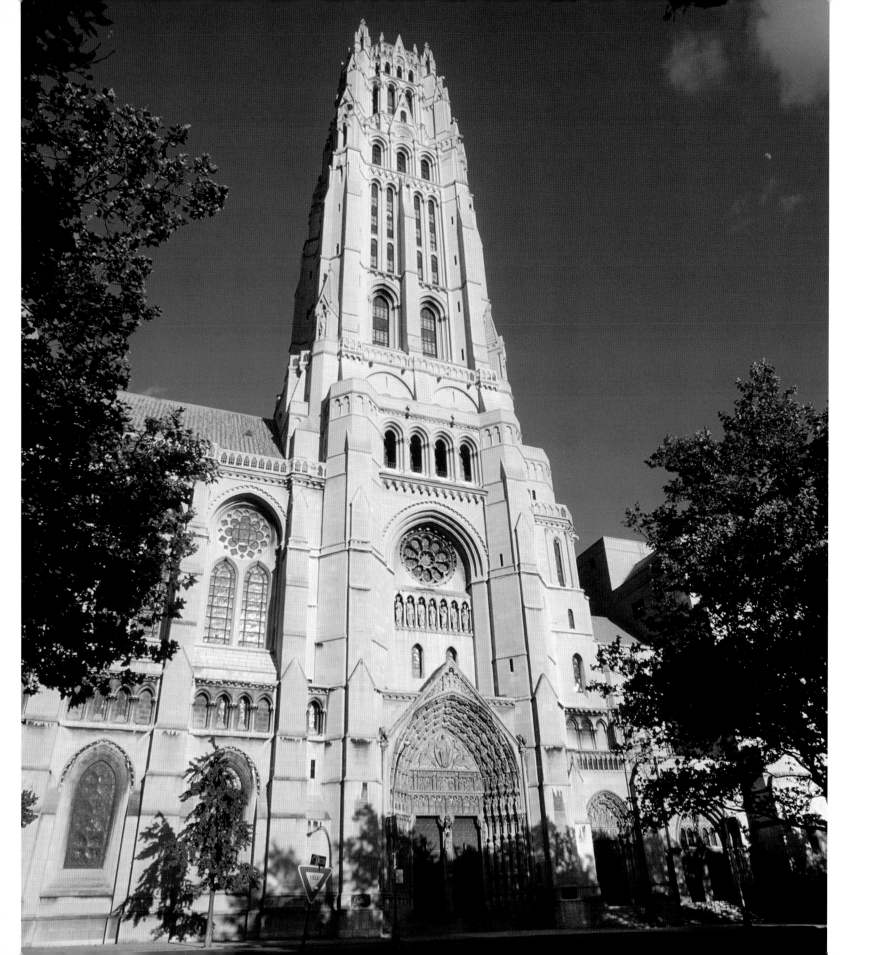

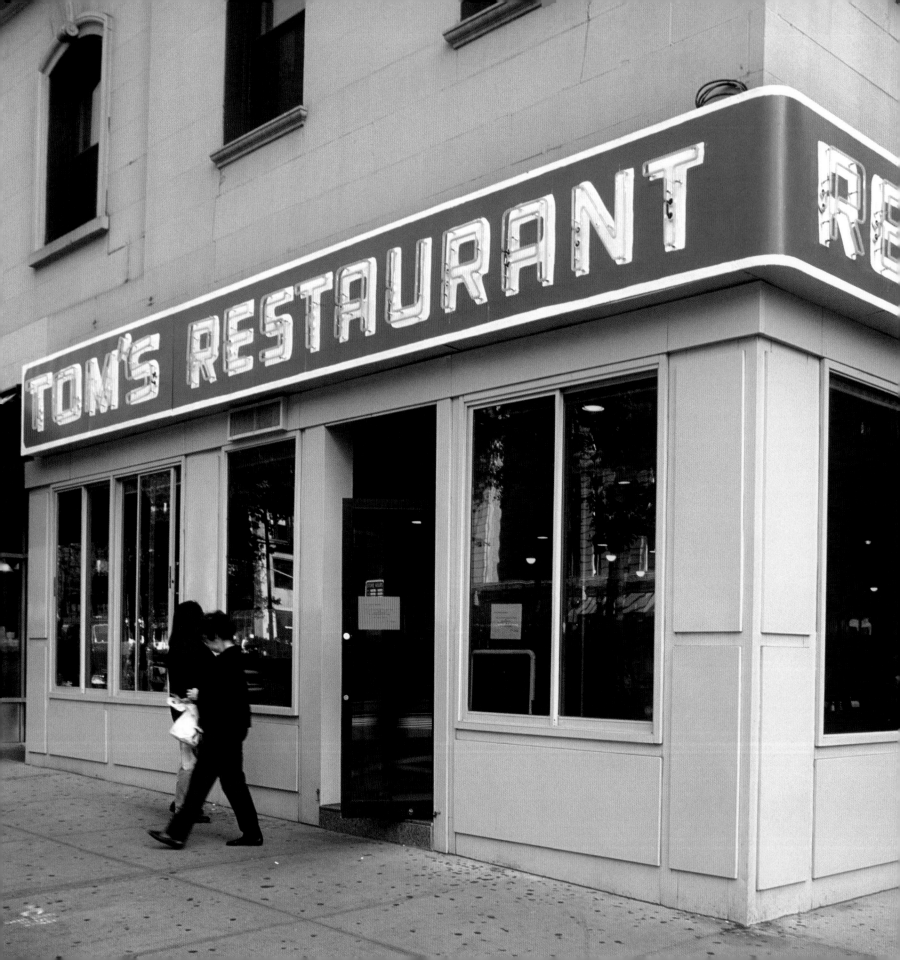

Tom's Restaurant is a popular diner located on Broadway at the corner of 112th Street. Frequented by students of nearby Columbia University, it is a shrine to fans of television's *Seinfeld* – who know that it stood in for the café where Jerry hung out with his friends.

BELOW: The Magnolia Bakery on Bleecker and West 11th Streets in the West Village is responsible for New York's cupcake craze. There's usually a lineup, and the bakery limits cupcake purchases to 12 per customer. The establishment has been featured in various television shows, including *Sex and the City*.

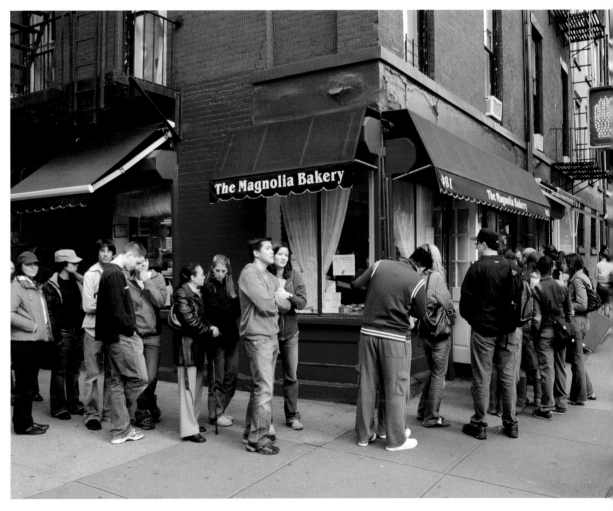

The White Horse Tavern in the West Village is a favorite haunt of students from nearby New York University. One of New York's oldest bars, it has a British pub atmosphere, which may be why the poet Dylan Thomas hung out here. Others who have enjoyed a drink at the White Horse include Bob Dylan and Jim Morrison.

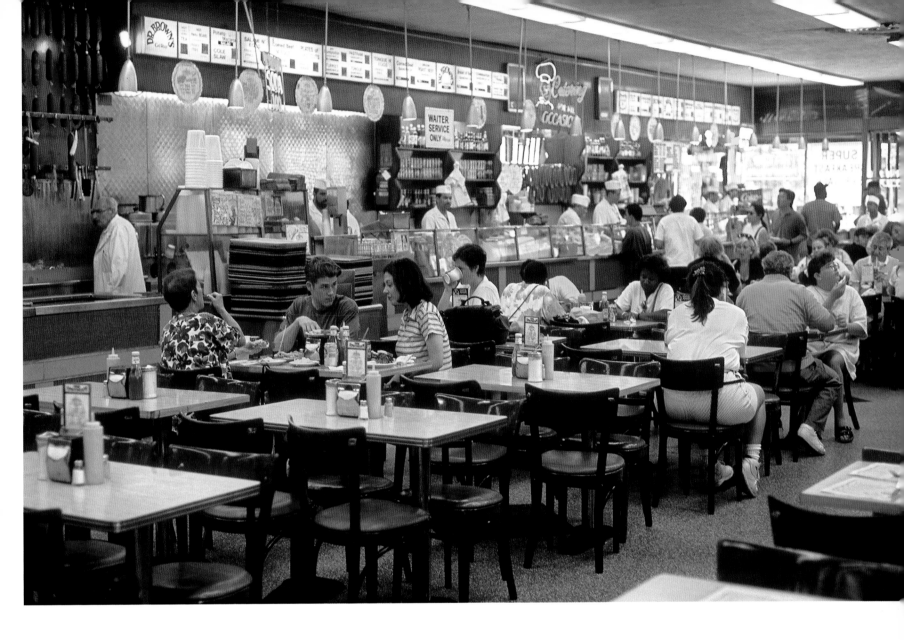

Katz's Delicatessen on Houston Street was made famous when *When Harry Met Sally* was filmed there. Delis are a New York institution, and Katz's is the oldest and among the best. The restaurant is renowned for its pastrami and corned beef, carved by hand, and is definitely a New York experience.

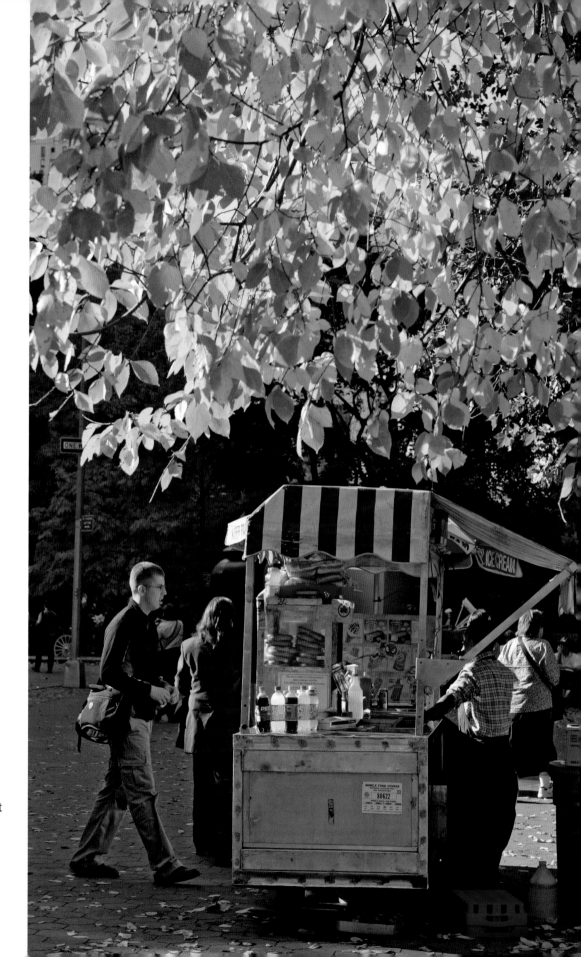

New York is famous for its street food. About 4,000 vendors offer such popular fare as soft pretzels, hotdogs and roasted chestnuts.

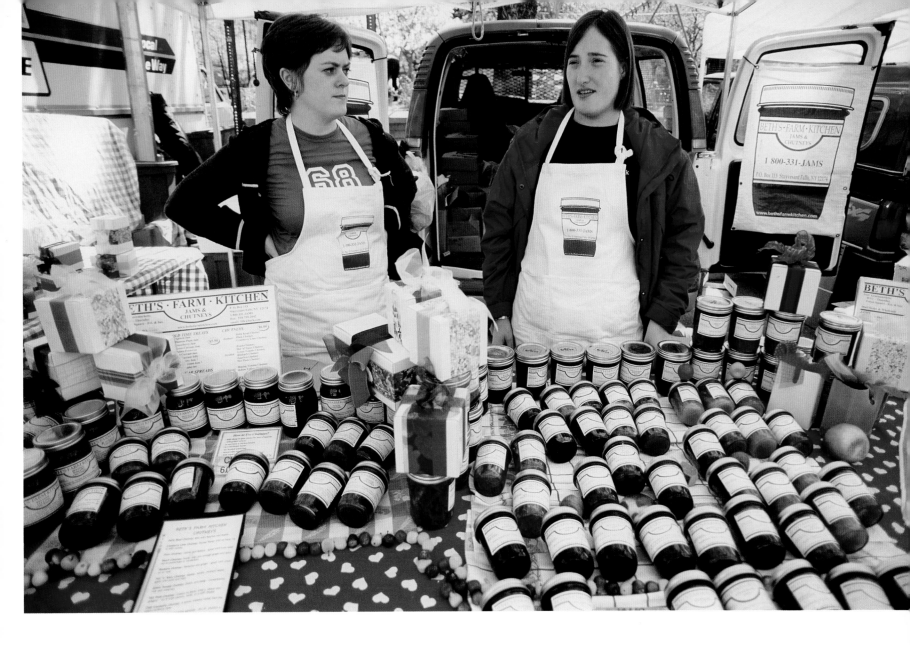

Farmers and other vendors bring their bounty – jams, produce, baked goods, meats, cheeses and more – to the Union Square Greenmarket. The market, which draws thousands of customers, operates year-round, four times a week.

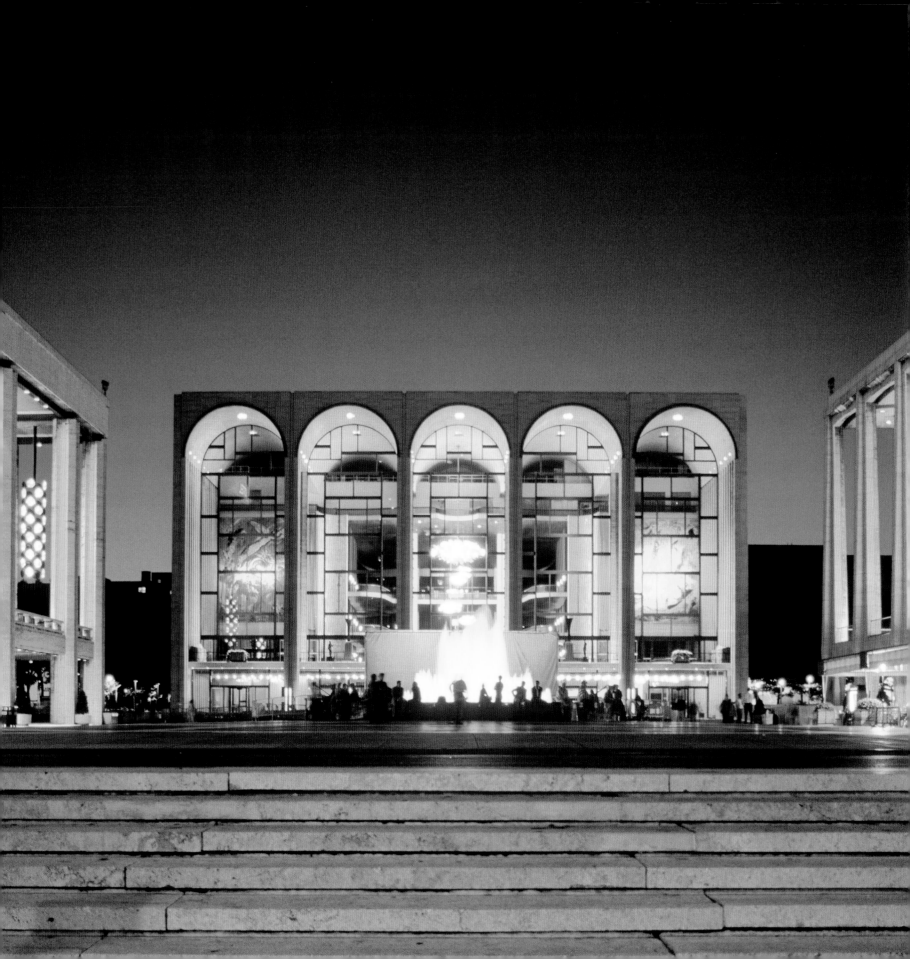

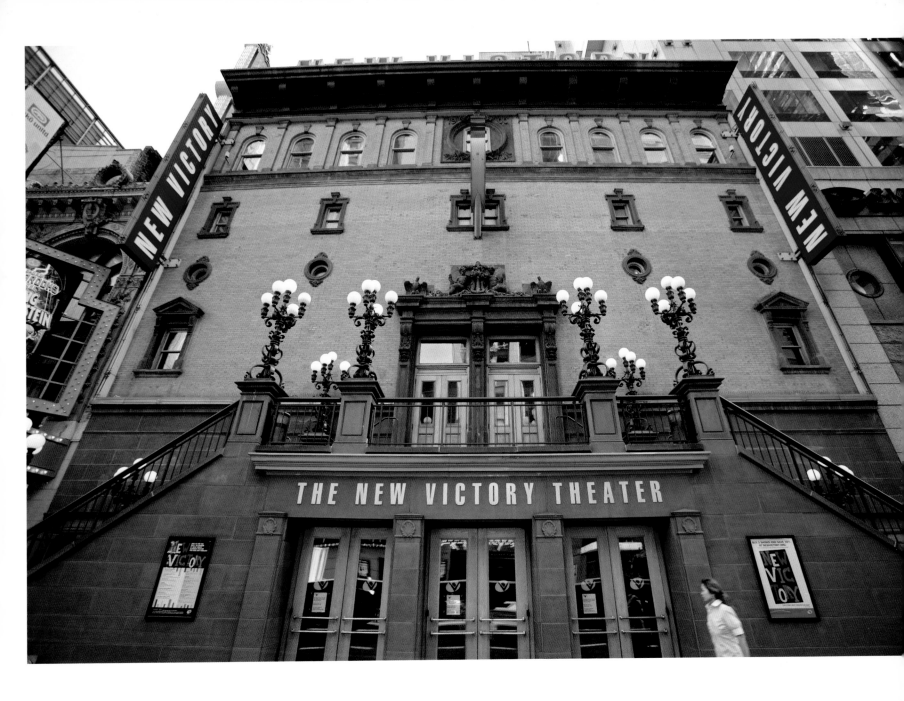

The first of several theaters to be restored in an effort to revitalize 42nd Street and Times Square, the New Victory Theater opened in 1995 as New York's first theater for kids and families.

OPPOSITE PAGE: Lincoln Center for the Performing Arts, the city's most important cultural center, includes buildings for dance, music and theater. The Metropolitan Opera House, home to the Metropolitan Opera Company and the American Ballet Theater, is fondly known as the Met. It boasts five arched windows and murals by Marc Chagall.

Radio City Music Hall, with a seating capacity of about six thousand, was the world's largest movie house when it was built in 1932. The Art Deco masterpiece boasts a marquee that's a full city-block long, and its shimmering gold stage curtain is the largest in the world. The Music Hall Christmas Show, a New York Christmas tradition since 1933, is a spectacular event featuring the world-famous women's precision dance team known as the Rockettes.

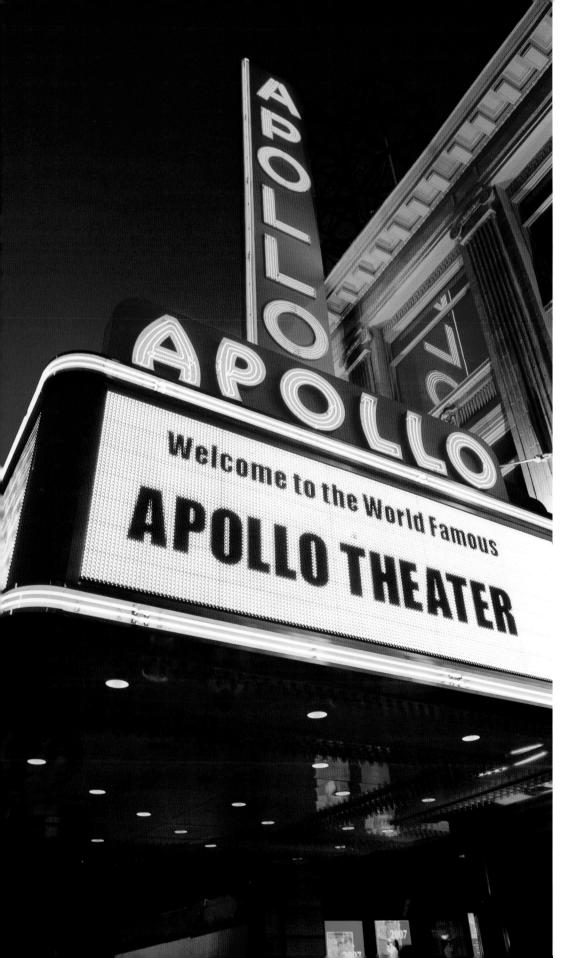

The Apollo Theater on 125th Street in Harlem is listed on the National Register of Historic Places. Winners of its amateur nights have included such greats as Ella Fitzgerald, Sarah Vaughan, Dionne Warrick, Gladys Knight and the Jackson Five. Called the place "Where Stars Are Born and Legends Are Made," the legendary theater draws an estimated crowd of 1.3 million visitors annually.

Located on Seventh Avenue between 56th and 57th Streets, Carnegie Hall was built by philanthropist Andrew Carnegie in 1891. It is one of the most famous concert venues in the world, recognized for its beauty, history and acoustics. Most of the great performers of classical music since the time it was built have performed here.

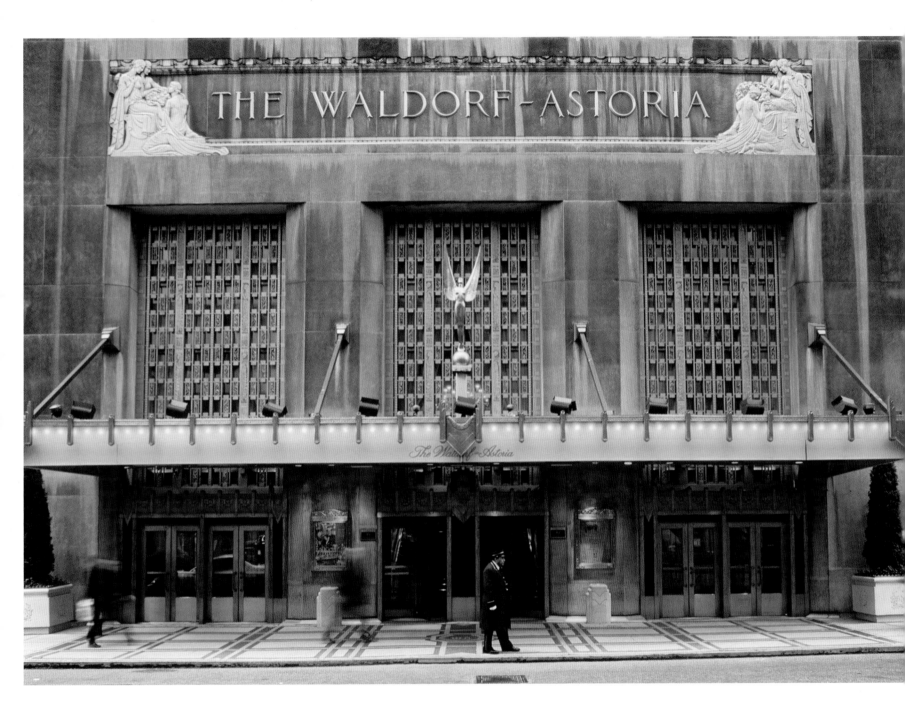

The Waldorf-Astoria on Park Avenue, considered one of New York's grand hotels, epitomizes elegance and luxury. The 47-story Art Deco landmark dates from 1931. Its upper section is known as the Waldorf Towers, a "hotel within a hotel" where, for many years, the Duke and Duchess of Windsor maintained an apartment.

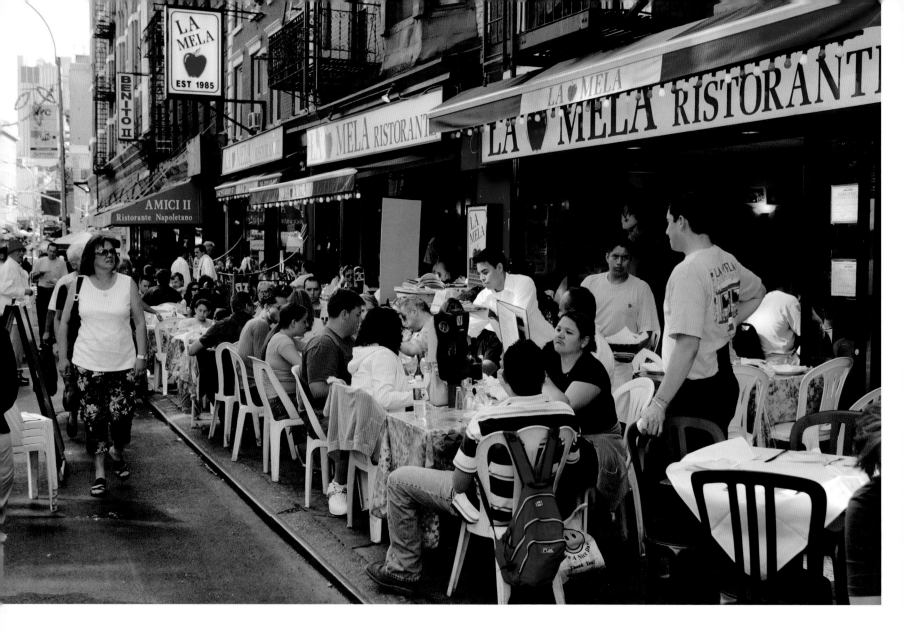

Little Italy in Lower Manhattan draws visitors to its Old World sidewalk cafés, bistros, bakeries and festivities. Mulberry Street is at the heart of the neighborhood.

OPPOSITE PAGE: Chinatown in Lower Manhattan is one of the largest outside of Asia. Both a tourist attraction and the home of many Chinese New Yorkers, it is a tightly packed neighborhood of winding streets bustling with restaurants, markets, bakeries and gift shops. The dragon dance shown here takes place during Chinatown's festive celebrations.

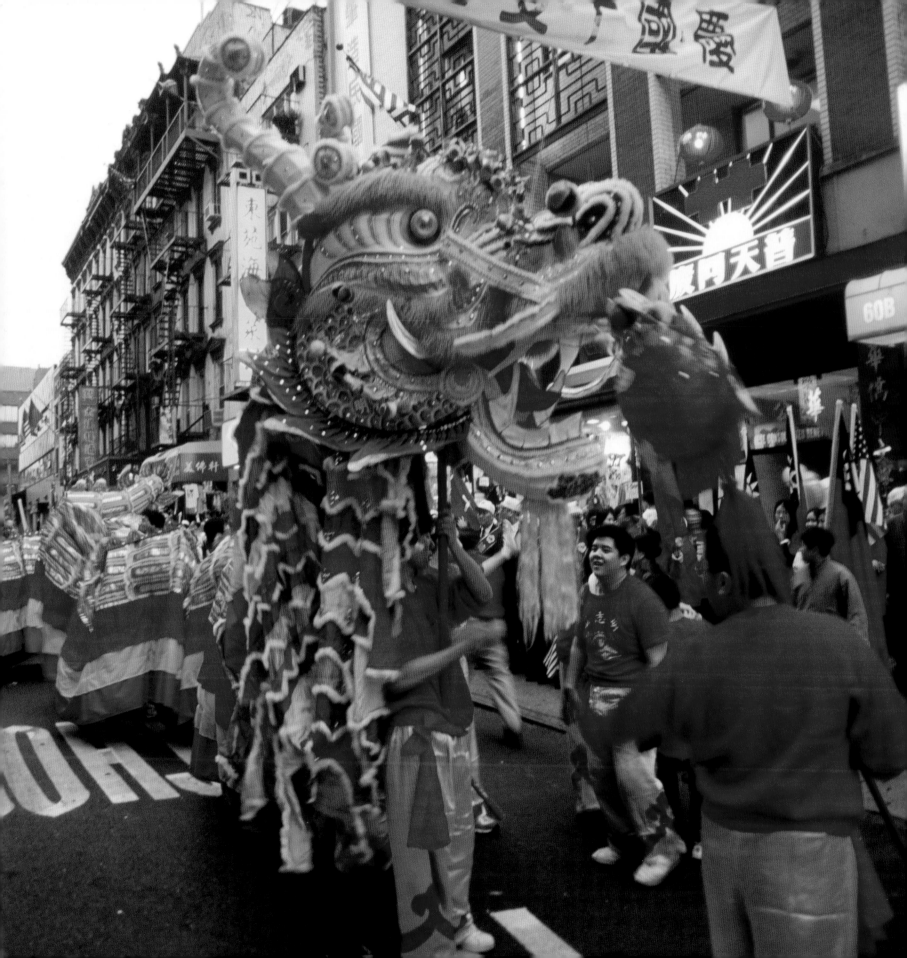

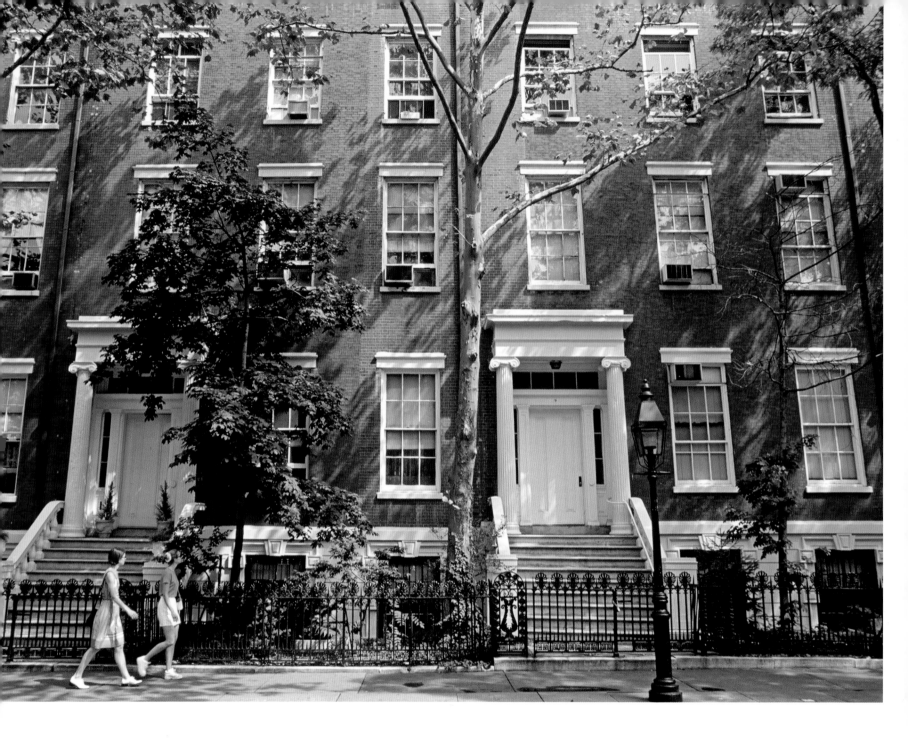

Washington Square in Greenwich Village is surrounded by townhouses, gardens and courtyards. With its leafy, winding streets, the area has the feel of a small European city.

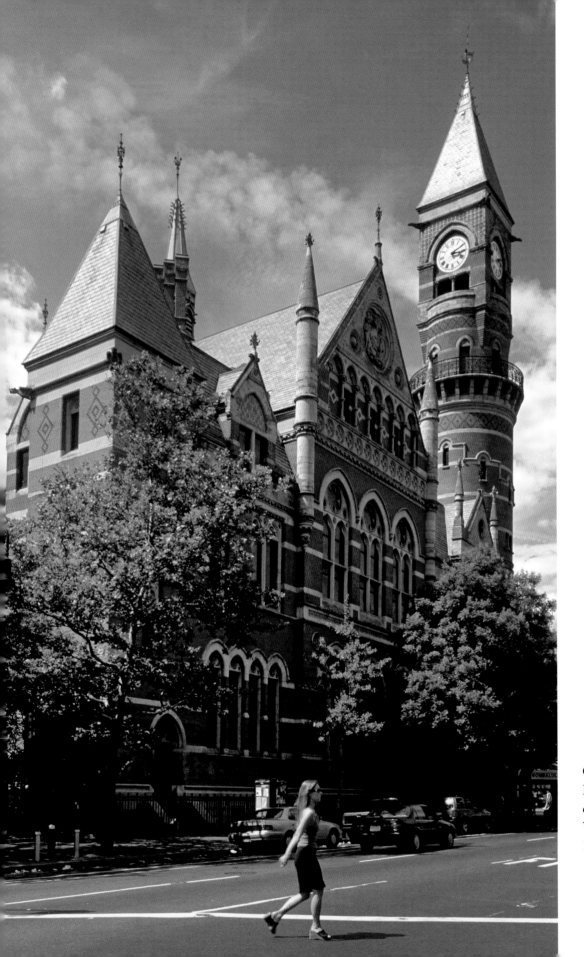

Originally a courthouse, the Jefferson Market Library has served the Greenwich Village community for more than 30 years. The Victorian Gothic building, erected between 1875 and 1877, is a New York City landmark.

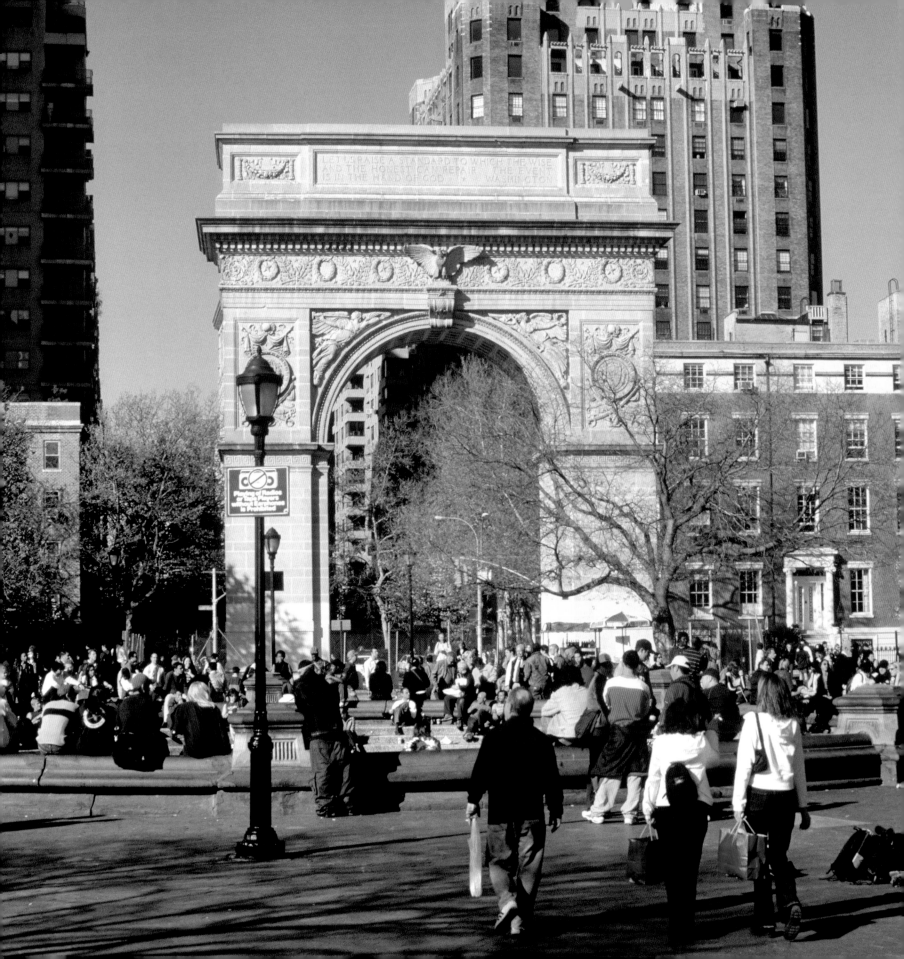

Brownstones in Harlem provide a glimpse into old New York. Originally a suburb for the well-to-do, Harlem includes a variety of housing. The area has long been known as an African-American residential, cultural and business neighborhood.

OPPOSITE PAGE: Washington Square Park in Greenwich Village is popular among students of nearby New York University. The "Village," where streets wind unpredictably, refusing to follow the city's usual grid pattern, is home to many artists, writers and musicians.

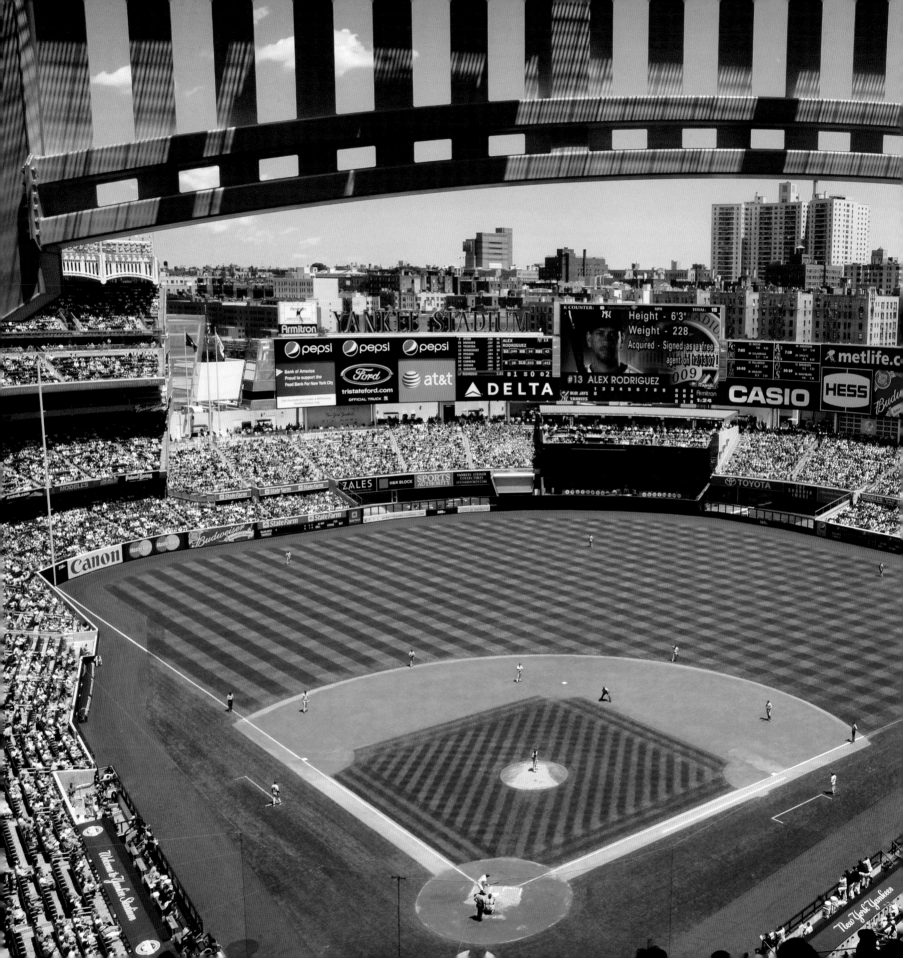

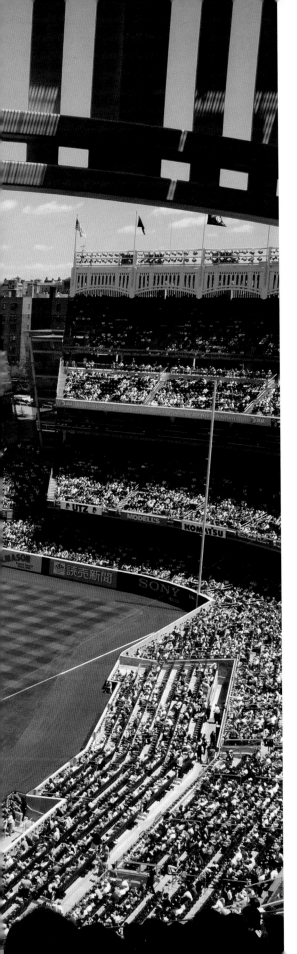

OPPOSITE PAGE: Yankee Stadium in the Bronx has hosted more World Series than any other baseball stadium in the country. In 2009, the original "House that Ruth Built" was replaced by a new structure, pictured here, which is located across the street from the original stadium and incorporates design elements from the team's previous home. As a sign of their approval, the Yankees won the first World Series played in their new stadium.

BELOW: The Unisphere is a giant steel globe that sits in Flushing Meadows–Corona Park in the borough of Queens. Known as the largest globe in the world, it was built as a symbol of world peace. The large park plays host to the New York Mets at Citi Field and the US Open tennis championship.

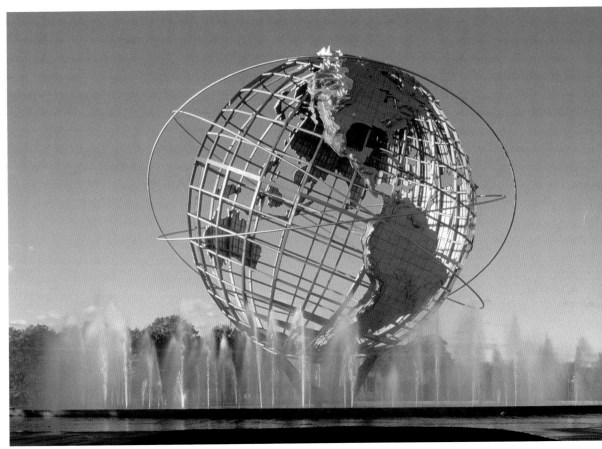

The New York Knickerbockers play their home games at Madison Square Garden, located above Pennsylvania Station. Often abbreviated as MSG, this is actually the Garden's fourth location in the city. In addition to being the home of the Knicks and hosting other sporting events, the arena is a venue for large-scale concerts.

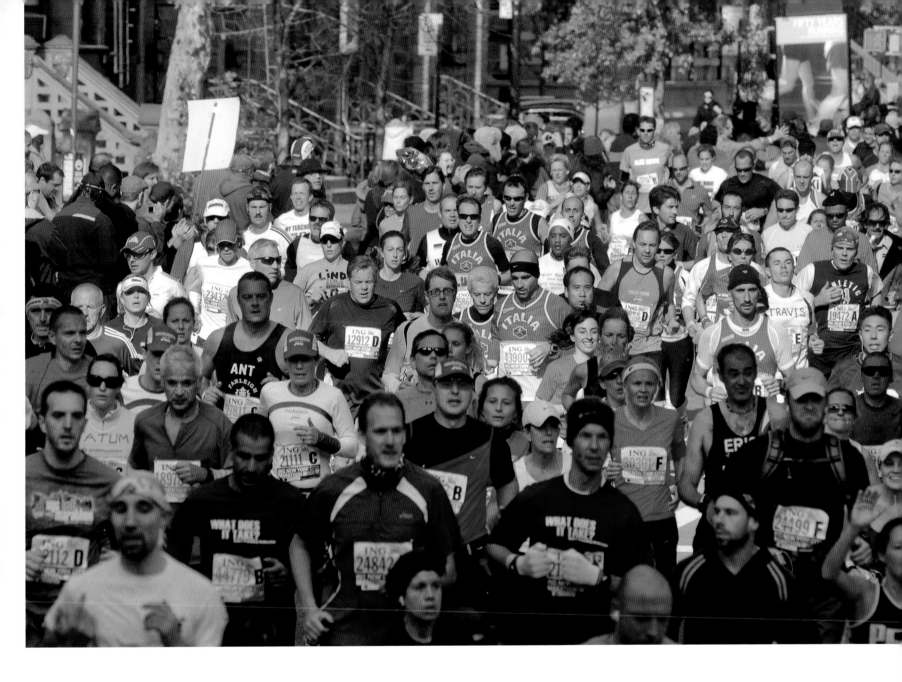

Runners pass through Harlem at the 22-mile marker in the New York City Marathon. The competitive event, the largest marathon anywhere, attracts thousands of runners from around the world. It takes place on the first Sunday in November, and its course runs through all five boroughs.

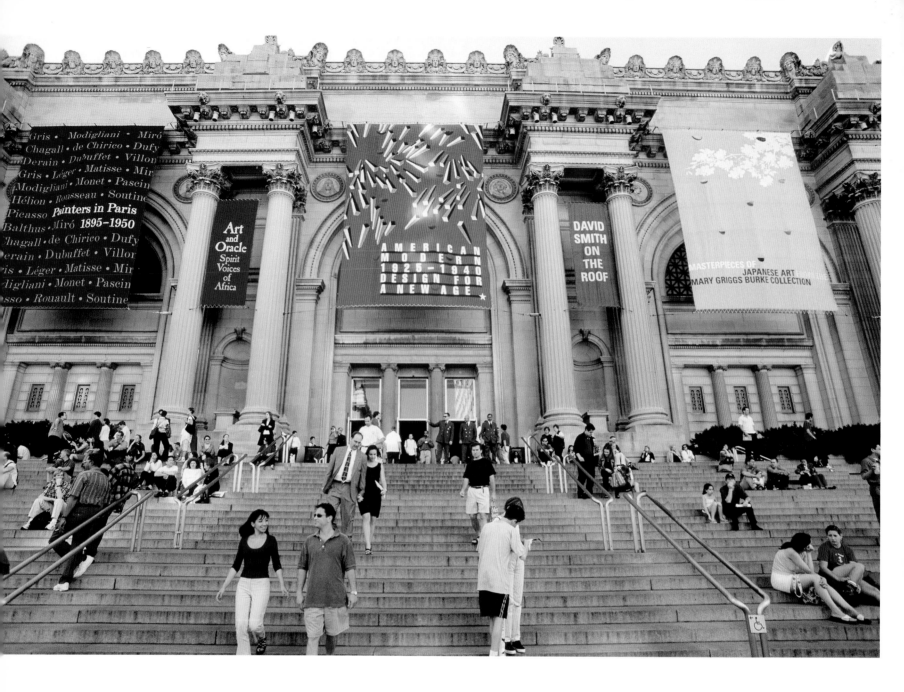

The Metropolitan Museum of Art opened in 1880 and now houses collections from all over the world. Located on Fifth Avenue along what is known as Museum Mile, the Met measures almost a quarter-mile long and offers more than two million square feet of gallery space.

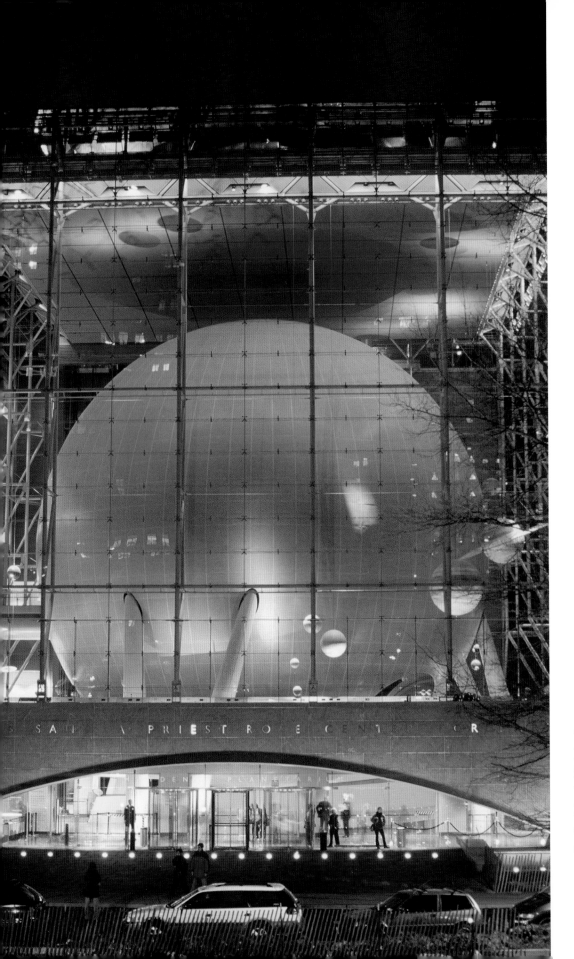

The American Museum of Natural History's Rose Center for Earth and Space opened in 2000 and is located on Central Park West. The center is the site of the new Hayden Planetarium, which offers sky shows in the world's most technologically advanced space theater.

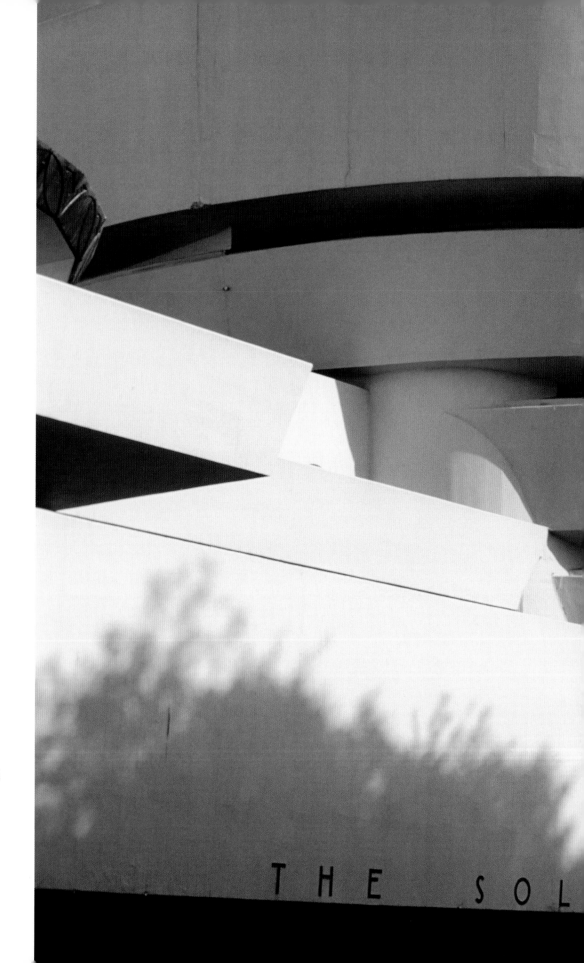

The Solomon R. Guggenheim Museum along the famed Museum Mile is a Frank Lloyd Wright masterpiece. An architectural landmark, this "monument to modernism" opened in 1959. The Guggenheim houses one of the world's greatest collections of modern and contemporary art.

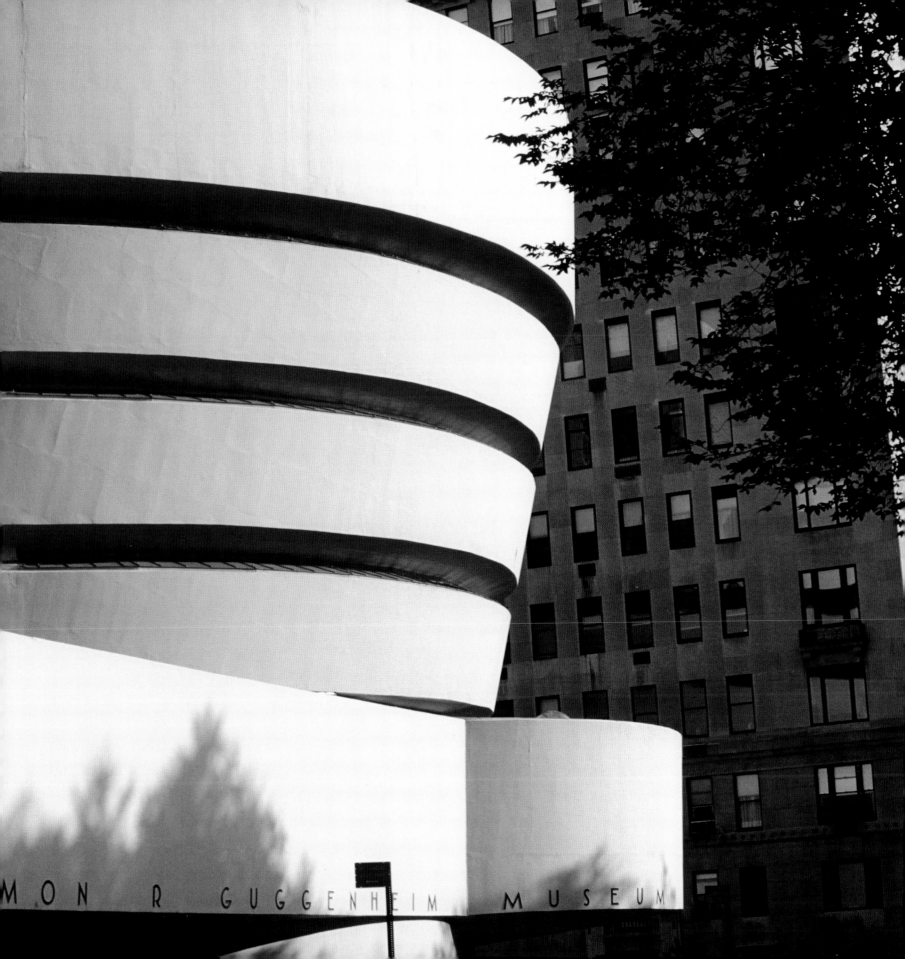

MON R GUGGENHEIM MUSEUM

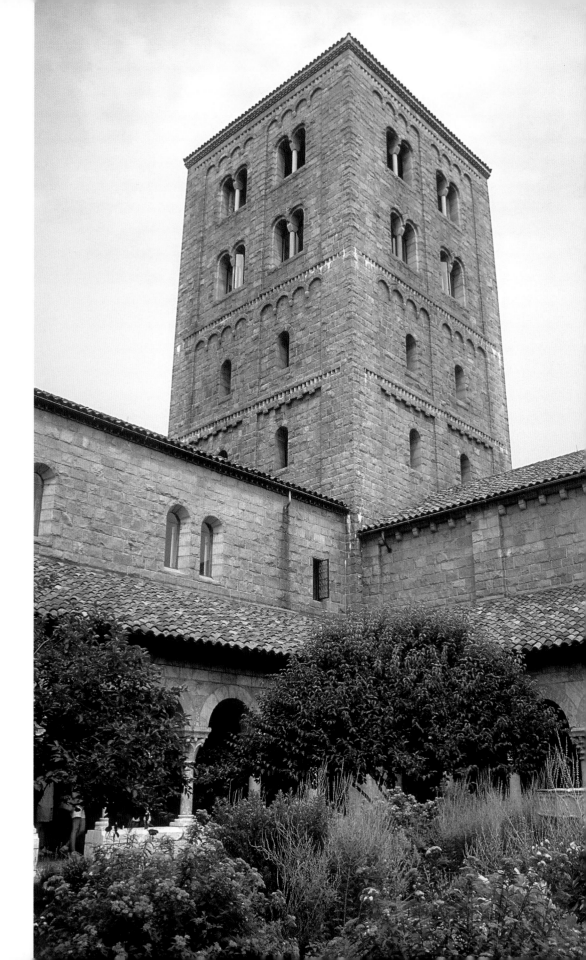

The Cloisters, located in Fort Tryon Park in Upper Manhattan, houses the medieval art collection of the Metropolitan Museum of Art. Constructed in the 1930s, the Cloisters incorporates actual medieval chapels shipped from Europe and includes the famous Unicorn Tapestries.

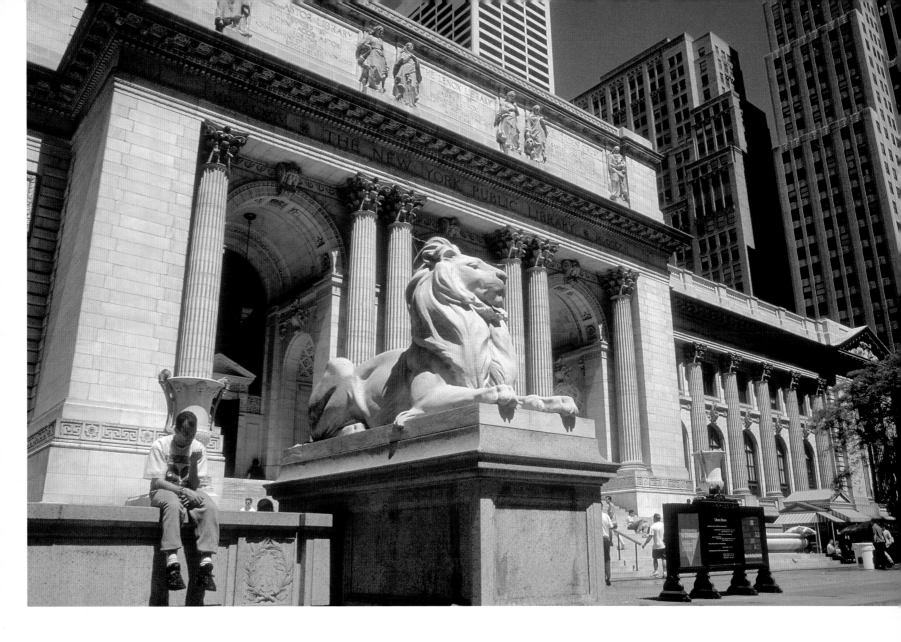

The world-renowned New York Public Library is located at Fifth Avenue and 42nd Street. Since the building was dedicated in 1911, a pair of marble lions have stood proudly before the majestic Beaux-Arts building. In the 1930s, New York's mayor named them Patience and Fortitude. Patience, pictured here, guards the south side of the Library's steps and Fortitude sits to the north.

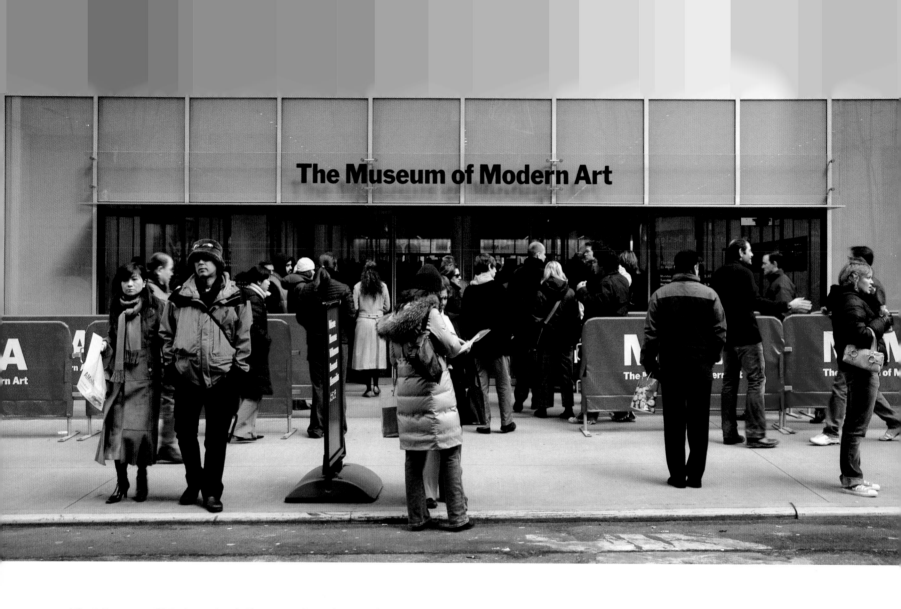

The Museum of Modern Art (affectionately nicknamed MoMA), located on West 53rd Street
near Fifth Avenue, houses the world's most comprehensive collection of 20th-century art.

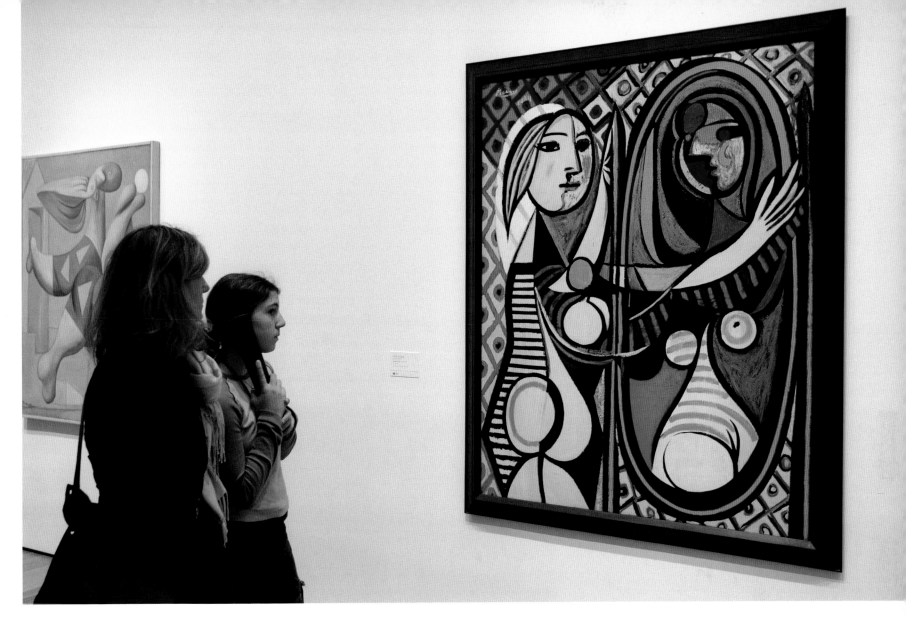

Visitors study *Girl Before a Mirror,* one of many works by Pablo Picasso on display at the Museum of Modern Art. Some think that the painting suggests the subject's day-self and night-self, while others see a woman confronting her own mortality.

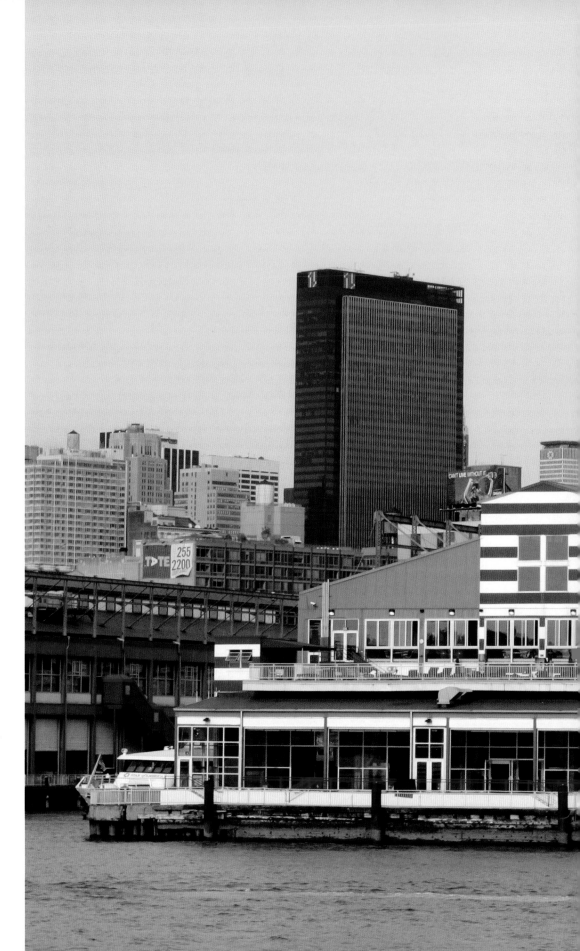

Chelsea, a neighborhood just below midtown, is home to many artists. Chelsea Piers is a series of historic piers on the Hudson River that formed a passenger ship terminal in the early 20th century. The piers – the destination of the *Titanic* – have been turned into a popular sports and entertainment facility.

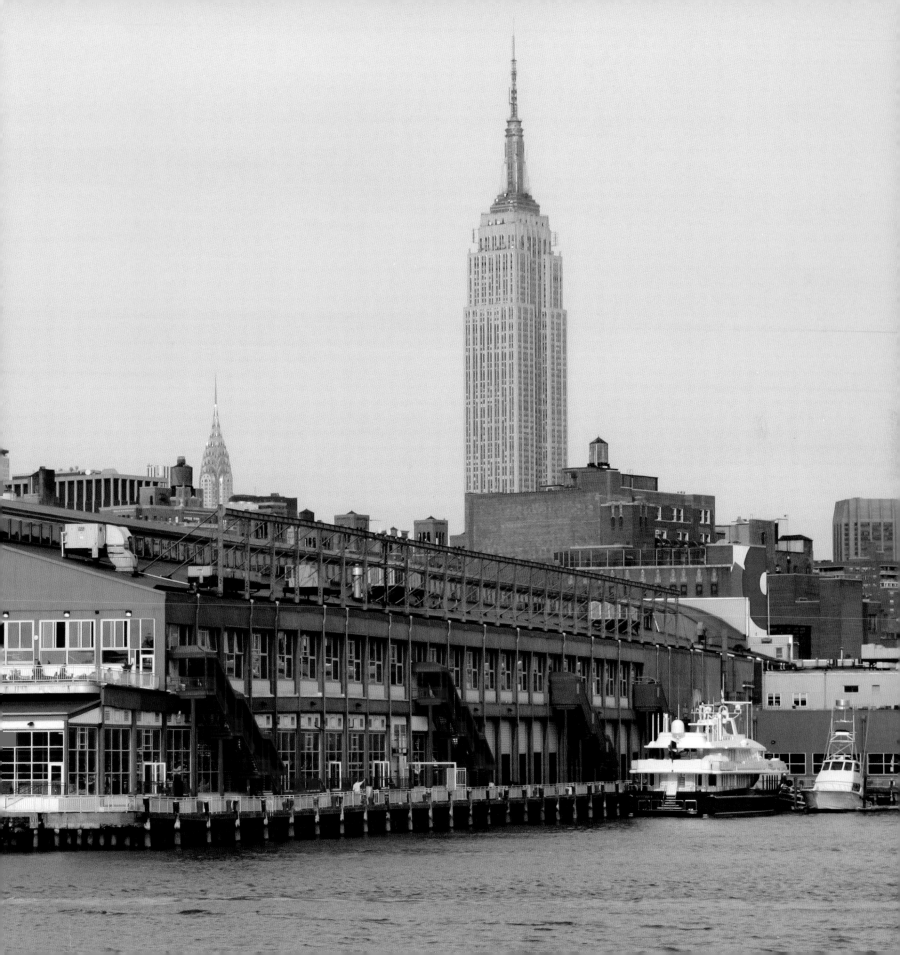

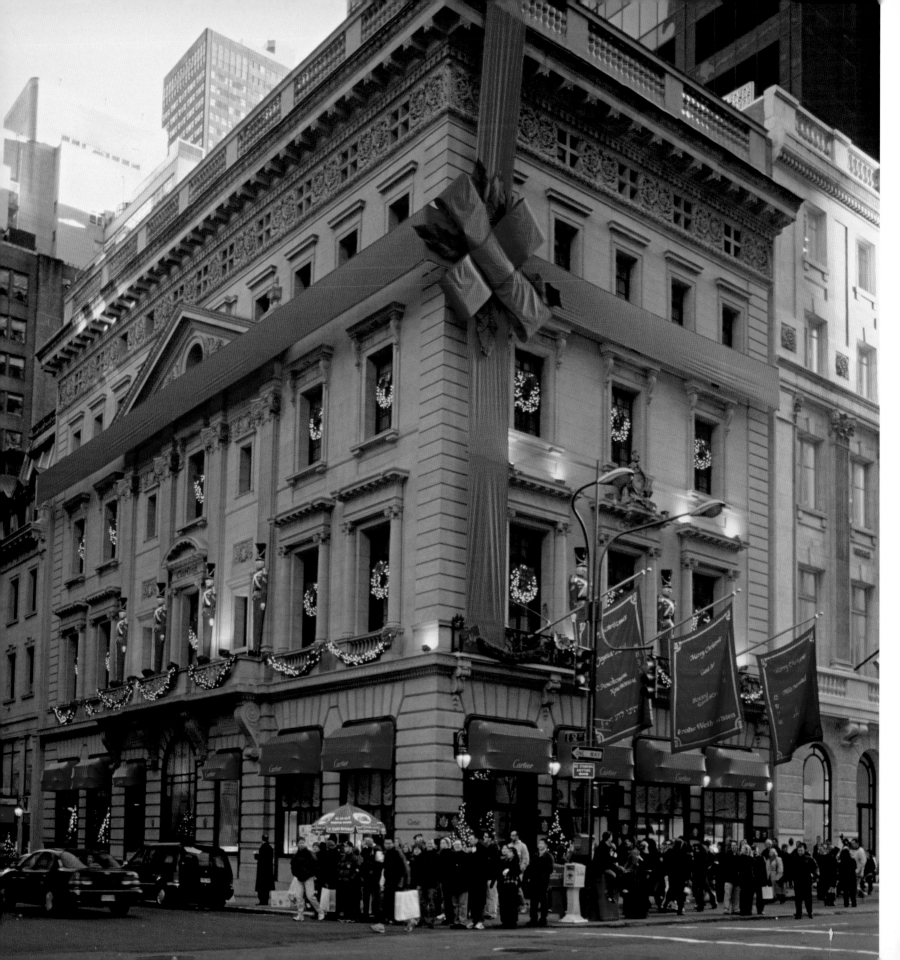

OPPOSITE PAGE: The stores along Fifth Avenue are among the world's most exclusive and include such upscale locations as Tiffany & Co., Saks Fifth Avenue and Cartier – the world's number-one seller of luxury jewelry. Cartier serves royalty and celebrities, and at Christmas it wraps itself up in a great big ribbon.

BELOW: Macy's, one of the world's foremost department stores, is a shopping icon. Located in bustling Herald Square, it takes up a full city block, occupies ten floors, and has half a million items for sale. The store was immortalized in the classic Christmas movie, *Miracle on 34th Street,* and here it is dressed up for the holidays.

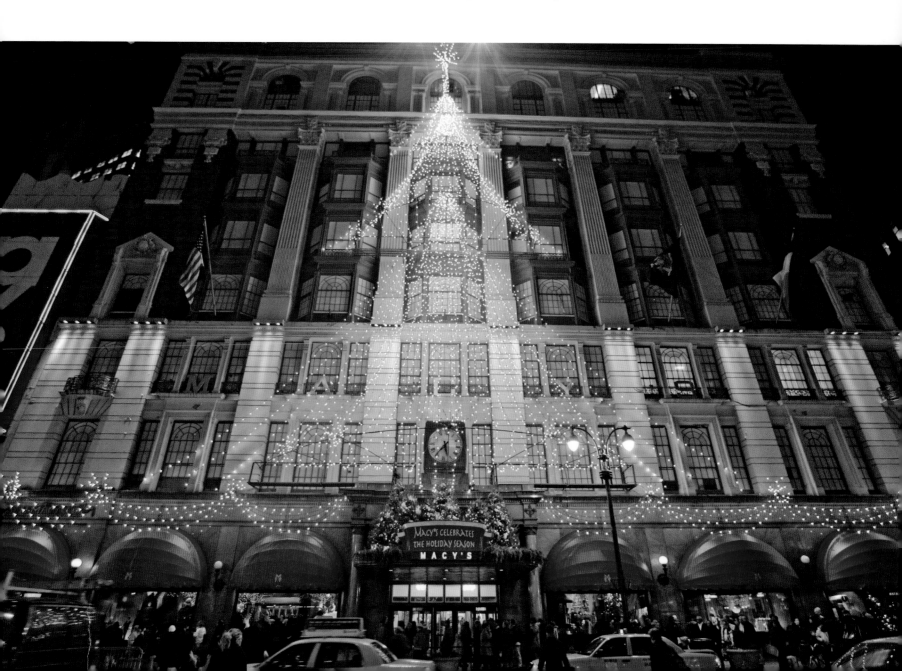

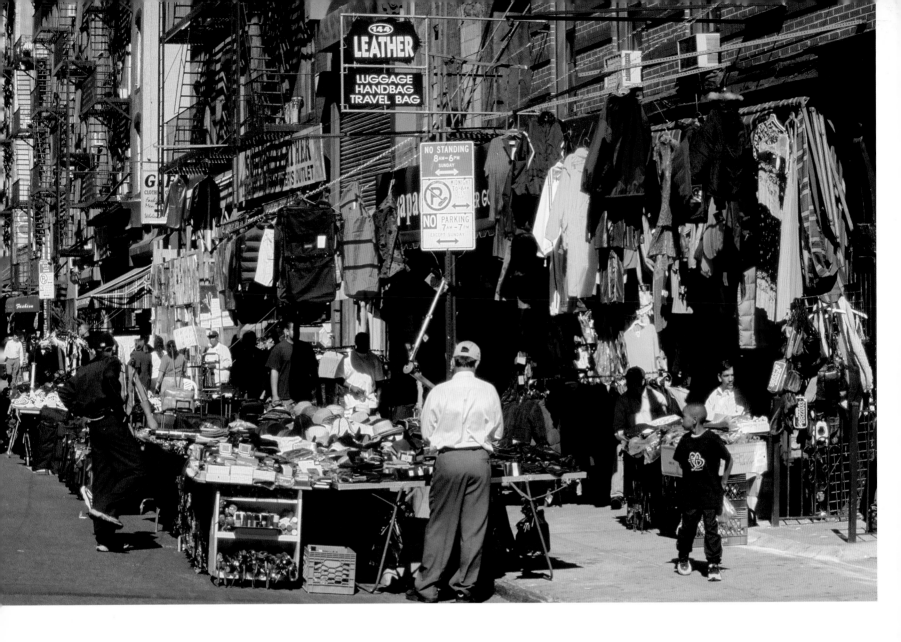

The Orchard Street Bargain District is located on the Lower East Side. Beginning in the late 19th century, millions of immigrants arrived in the area. Today, trendy shops compete with bargain stores and stalls. Along with the Old World flavor, shoppers will find designer clothes, shoes and accessories.

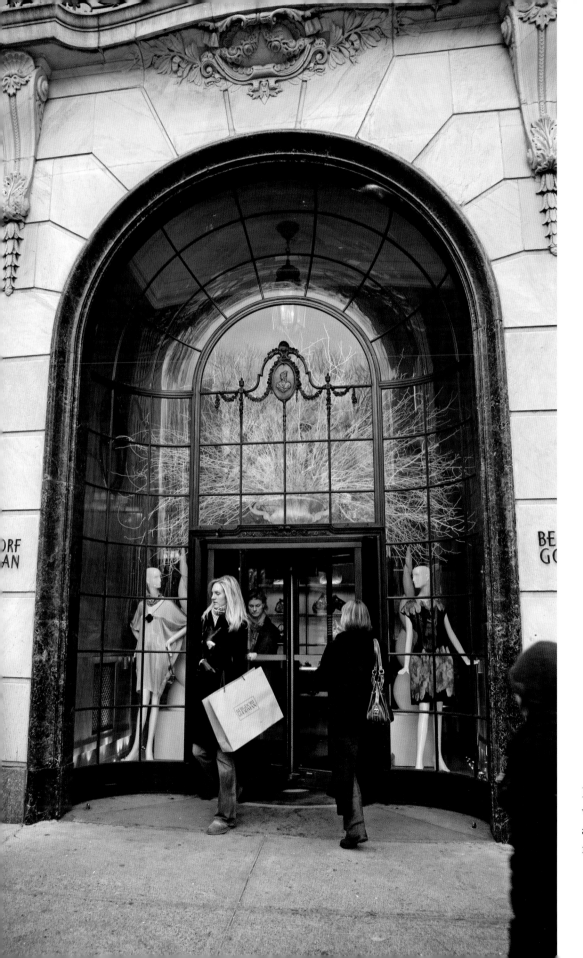

Bergdorf Goodman Department Store, which specializes in high-end women's apparel, is situated on prime Fifth Avenue real estate at 58th Street.

SOHO, which stands for South of Houston (pronounced How-ston) Street, was once the home of factories and warehouses. The artists who discovered the area can no longer afford the soaring rents, and today SOHO offers upscale restaurants, shops, bars and boutique hotels.

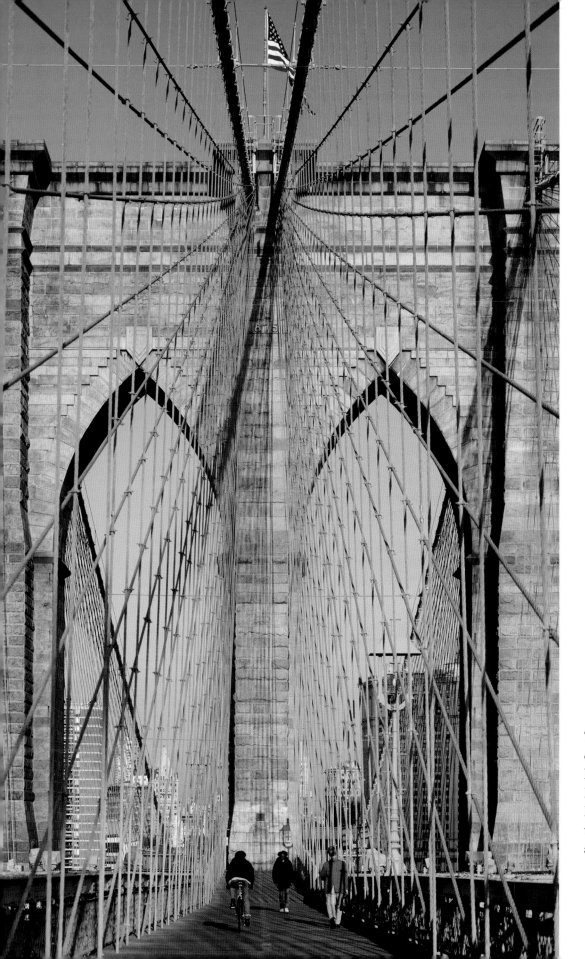

The Brooklyn Bridge, a legendary feat of engineering and a photographer's delight, links the boroughs of Manhattan and Brooklyn. It was built in 1883 – when Brooklyn was a separate city – and its walkway is popular with both pedestrians and cyclists.

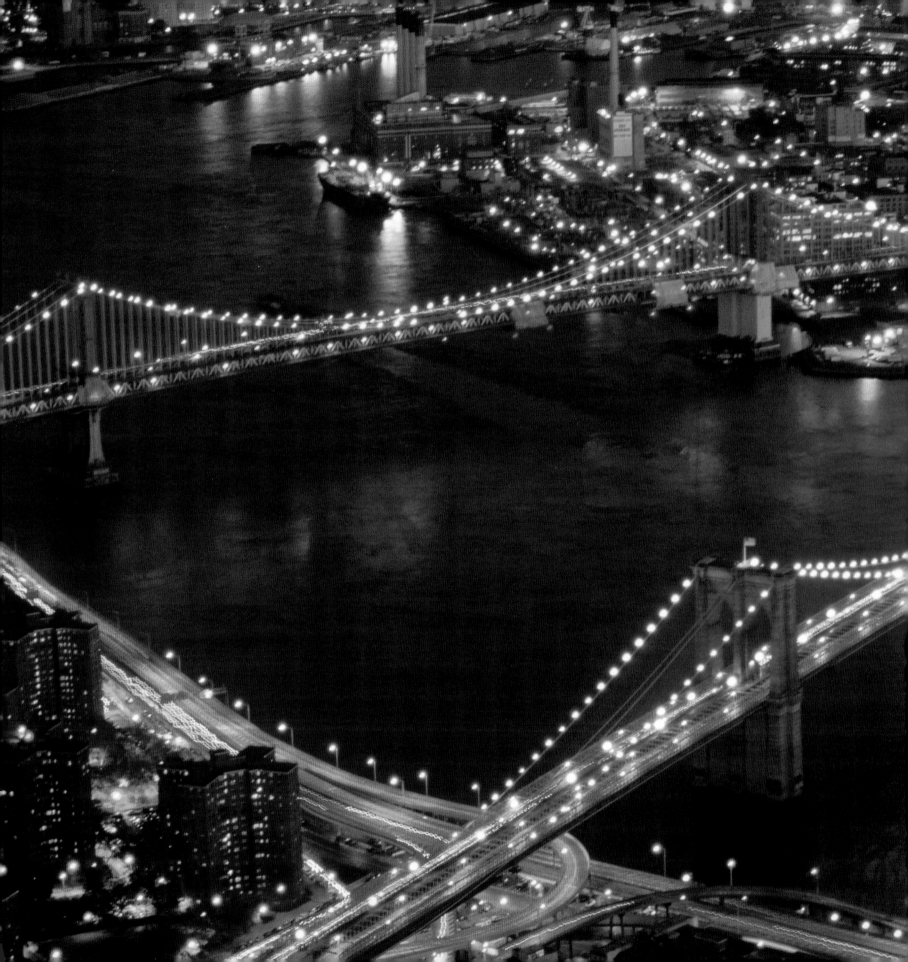

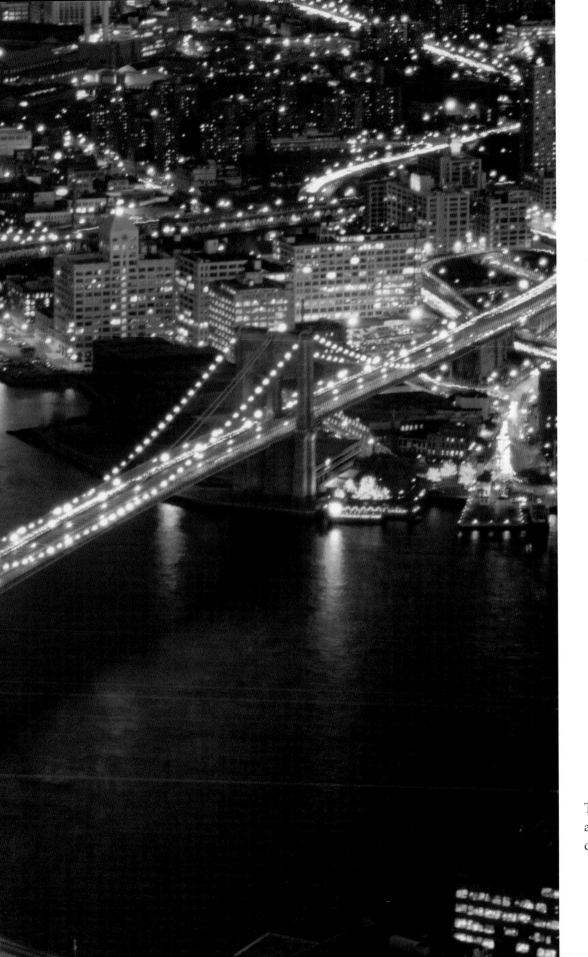

This aerial view shows the Manhattan (left) and Brooklyn Bridges lit up like strings of diamonds across the lower East River.

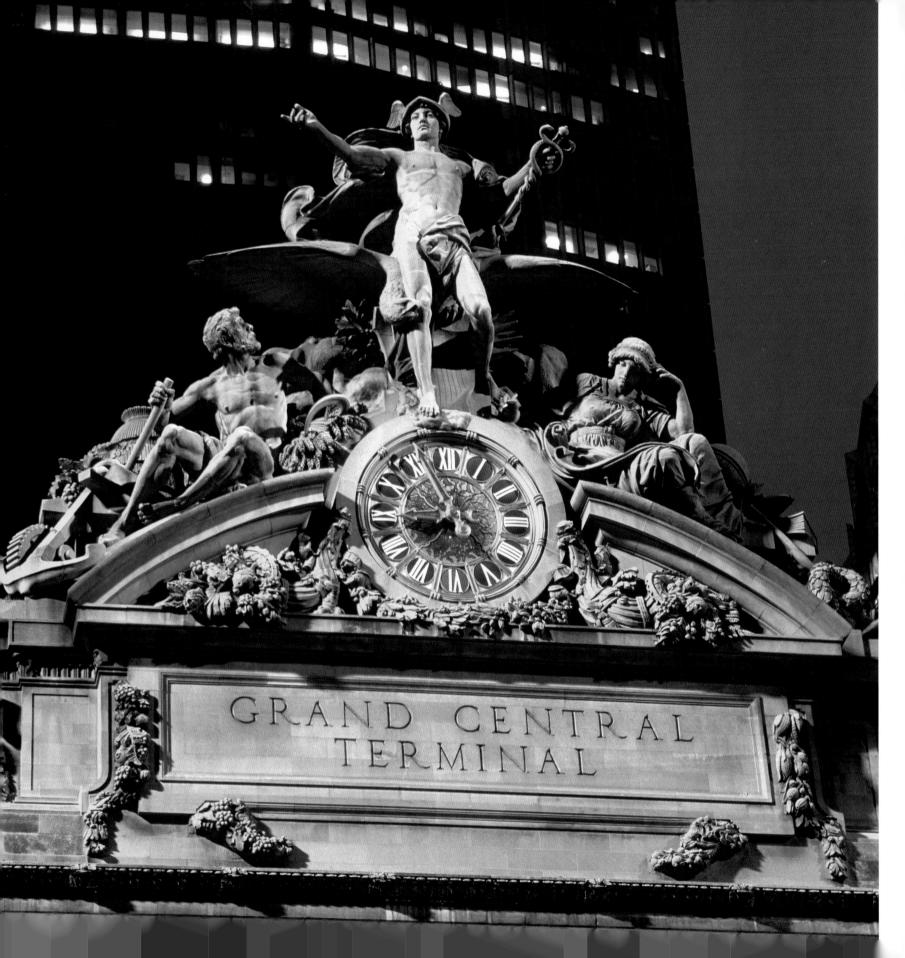

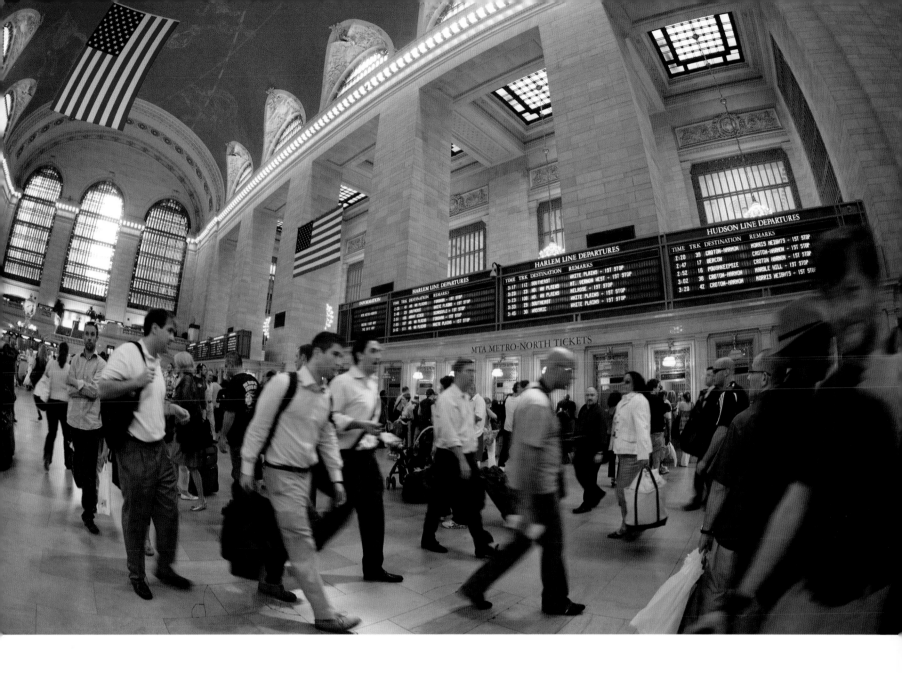

The immense interior of Grand Central Terminal was recently restored to its original grandeur. Grand Central is the largest in the world in terms of number of platforms, and the main concourse is 125 feet high. The terminal was once slated for demolition, but Jacqueline Kennedy and other preservationists had it declared a landmark. The large U.S. flag was hung in the terminal a few days after the September 11th attacks.

OPPOSITE PAGE: The facade on Grand Central Terminal's exterior boasts the world's largest example of Tiffany glass, as well as the world's largest sculptural group. Surrounding the 13-foot clock – designed in 1913 – are statues of Hercules, Mercury and Minerva.

New Yorkers prefer to travel by taxi or subway than to fight the city's relentless traffic. Yellow Cabs are yellow because the company's founder learned that the color was the easiest for the eye to identify.

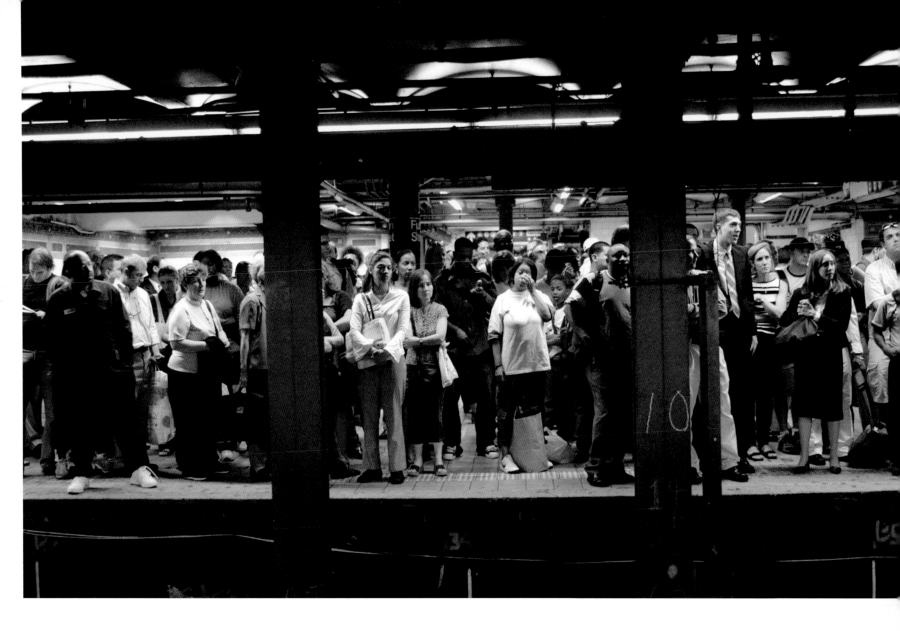

Crowds of subway riders wait for the IRT Lexington Avenue train at the Fulton Street station. An average of 4.9 million people ride the New York City subway each weekday. Unlike most major subway systems, New York's runs 24 hours a day.

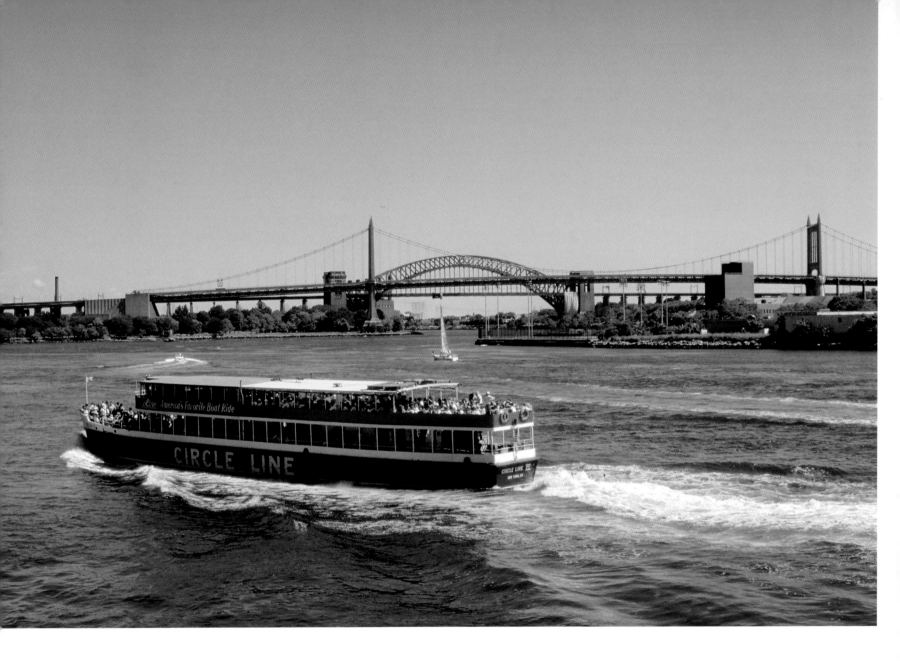

Riding the Circle Line is a popular way of seeing the city's landmarks. Seen in the background is the Hell Gate Bridge, which connects the borough of Queens with Randall's and Wards Islands.

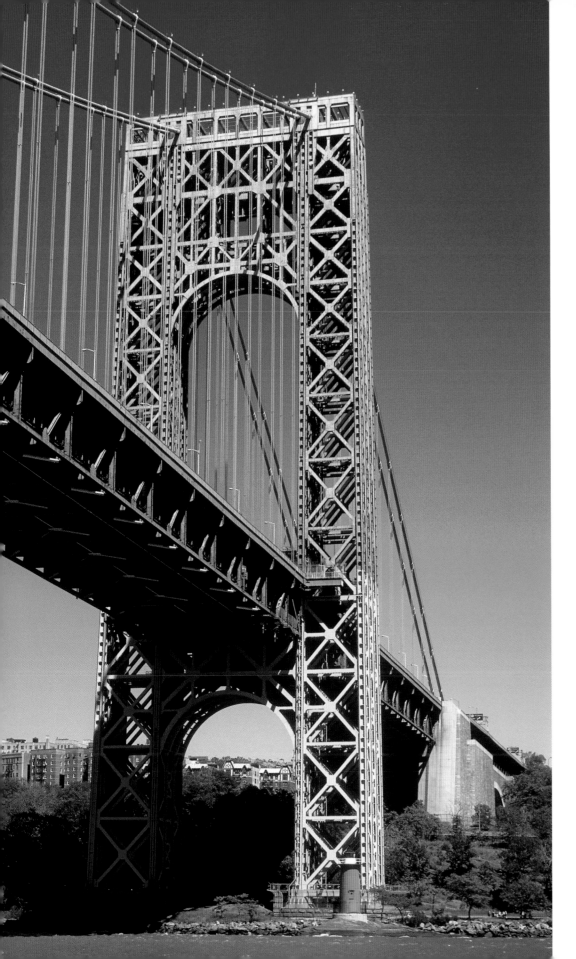

The George Washington Bridge spans the Hudson River, connecting Washington Heights in Upper Manhattan with New Jersey. The GWB, as it's popularly called, carries over 100 million vehicles yearly. The Little Red Lighthouse, located on the Manhattan side, was made popular by a children's book, *The Little Red Lighthouse and the Great Gray Bridge.*

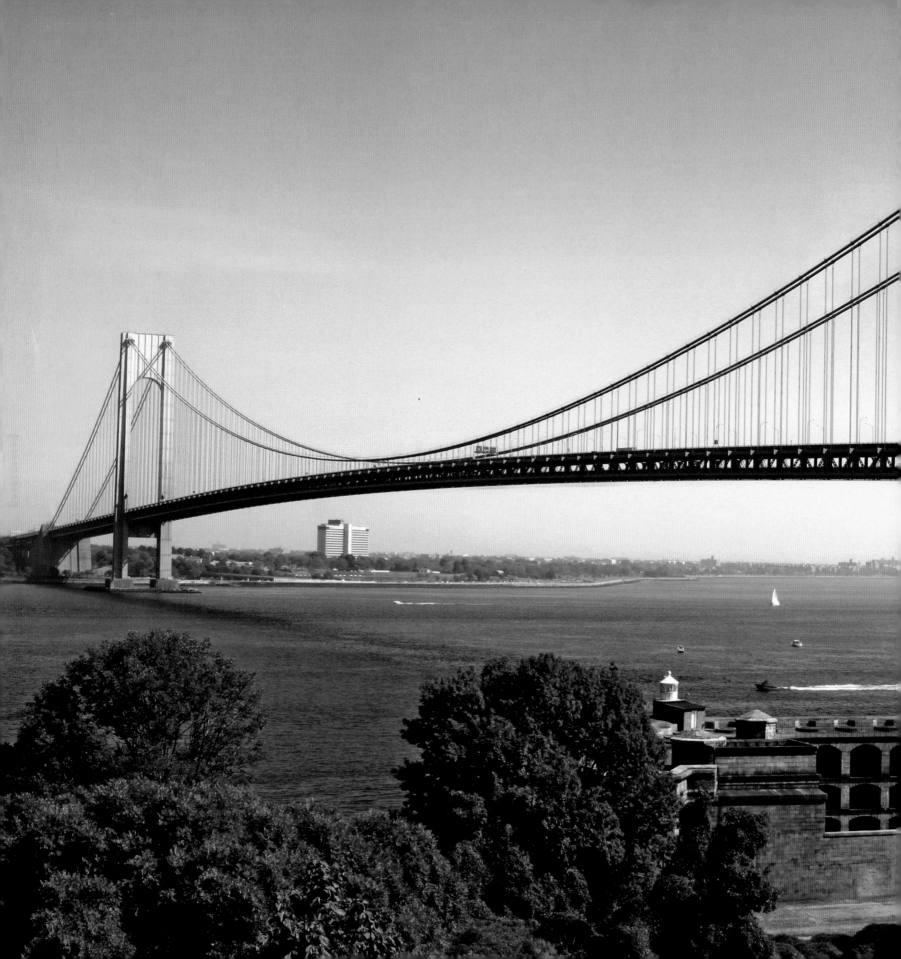

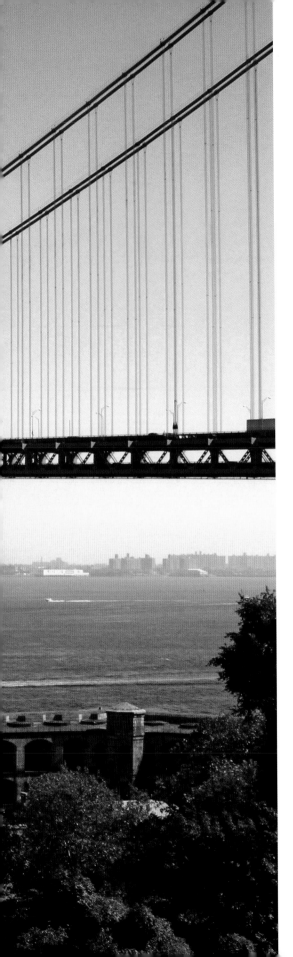

The graceful Verrazano-Narrows Bridge connects Brooklyn and Staten Island, the most rural of the city's five boroughs. It is named for Giovanni da Verrazzano, the first European explorer to sail into New York Harbor. Although no longer holding the title, it was the largest suspension bridge in the world when it opened in 1964.

BELOW: The NY Waterway ferry system provides tourist excursions along with a commuter service that shuttles passengers between New Jersey and Manhattan. In 2009, the company was recognized for its efforts to rescue passengers from US Airways Flight 1549.

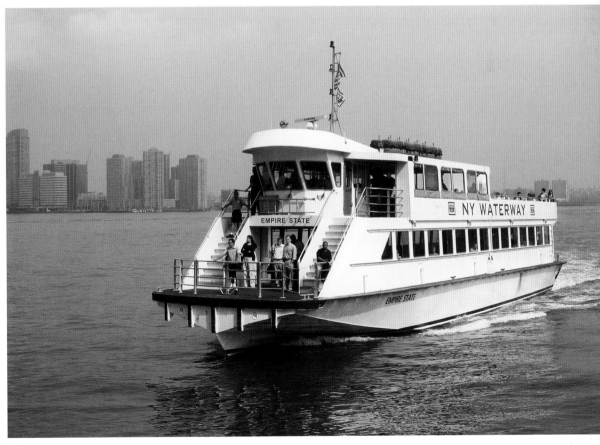

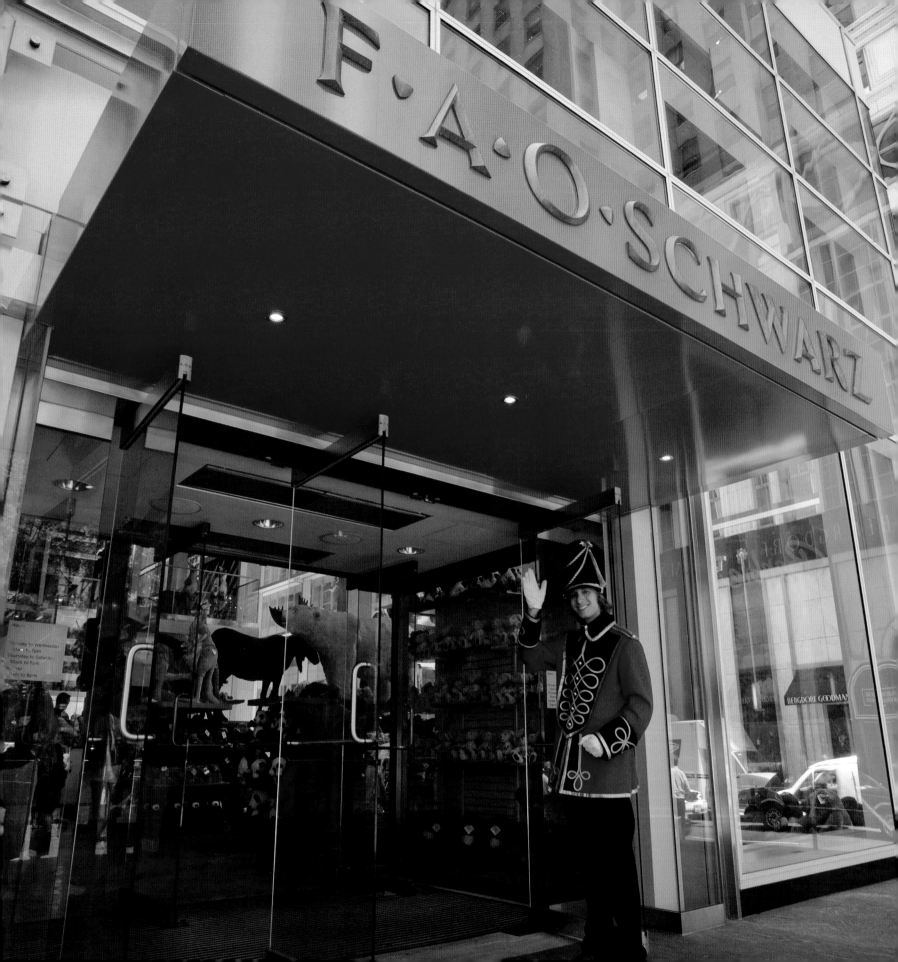

FAO Schwarz was featured in the 1988 movie *Big,* in which Tom Hanks danced "Heart and Soul" and "Chopsticks" on the store's large interactive piano. Visitors are invited to do the same.

OPPOSITE PAGE: FAO Schwarz, founded in 1862, is a world-famous toy emporium on Fifth Avenue that invites kids of all ages to "experience toys beyond your imagination." A toy soldier greets visitors, and the store is filled with huge stuffed animals, games, dolls and new and traditional toys.

Children are enthralled as they watch a polar bear scratch its back at the Bronx Zoo. The largest metropolitan zoo in the country, the Bronx Zoo is made up of 265 acres of parklands and naturalistic habitats and is home to more than four thousand animals, many of them endangered species.

OPPOSITE PAGE: The American Museum of Natural History on Central Park West, made up of 25 interconnected buildings, houses the largest collection of fossil mammals and dinosaurs anywhere. The museum, one of New York's most popular attractions, describes its display as dinosaur heaven.

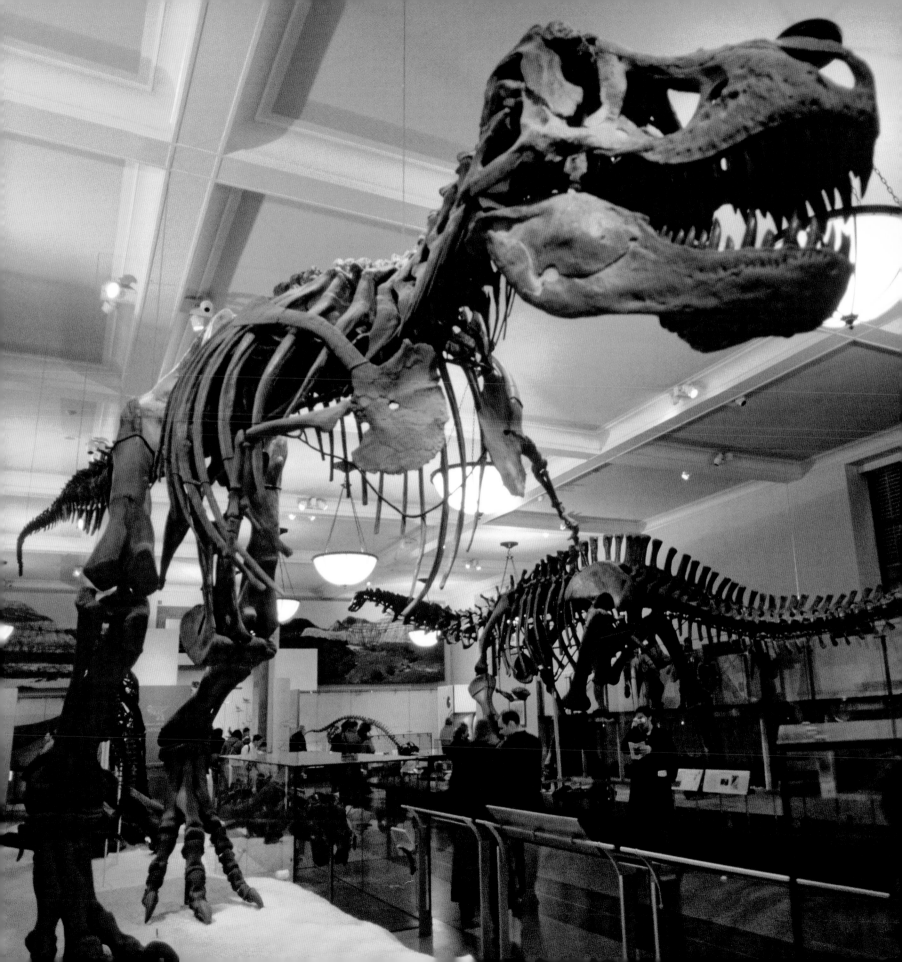

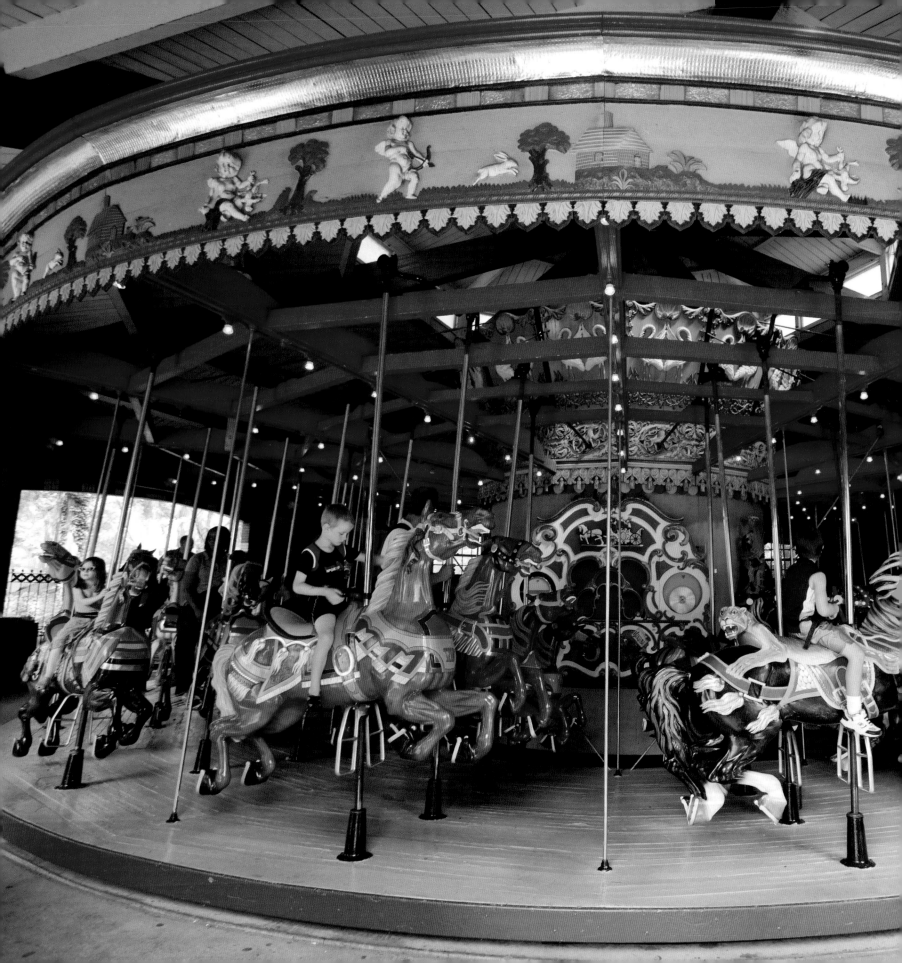

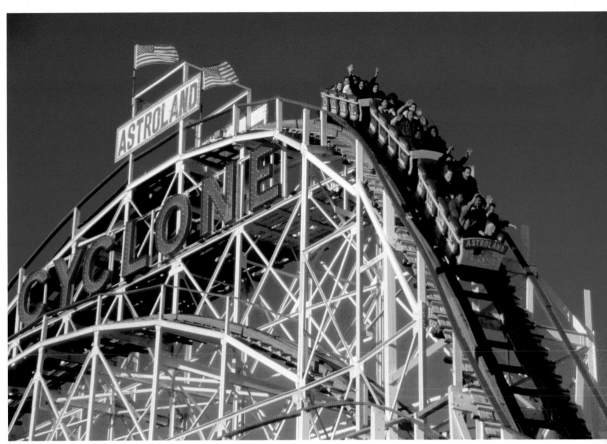

ABOVE: The Cyclone in Brooklyn's Coney Island is one of the world's great roller coasters. The historic wooden ride was built in 1927 and has been declared a New York City landmark. In its heyday, Coney Island was a major oceanfront resort and the site of amusement parks.

The original Central Park carousel opened in 1871 and was pulled by a mule and a horse. The current carousel, built in 1951, is one of the country's largest merry-go-rounds, featuring 58 hand-carved horses and two ornate chariots.

One of the most popular statues in Central Park is that of the master storyteller, Hans Christian Andersen. Kids love to crawl into the lap of the great Danish author, who is accompanied by his famous duckling companion.

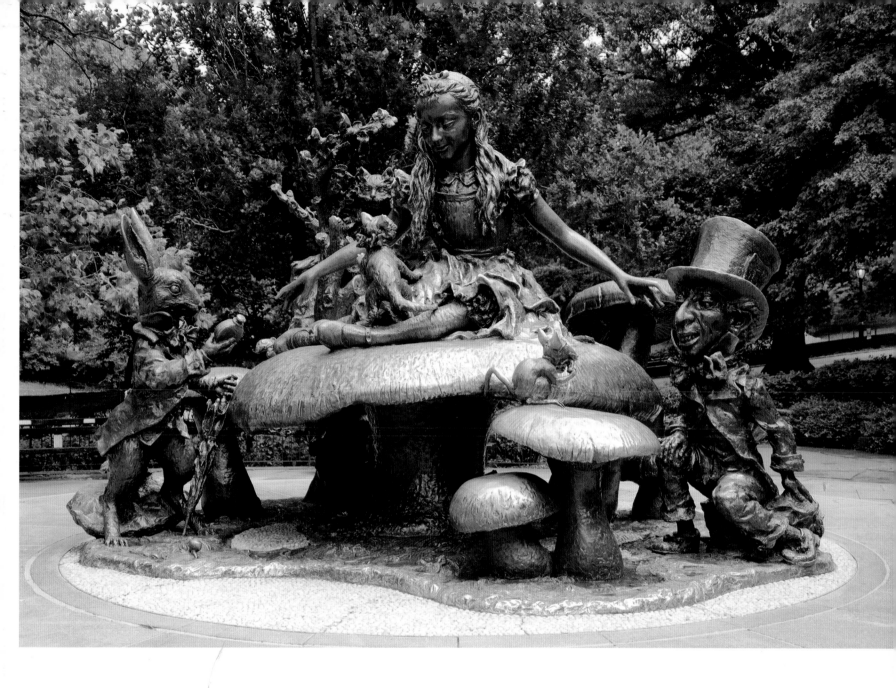

Lewis Carroll's *Alice in Wonderland* comes to life in this delightful Central Park sculpture, commissioned in 1959 and beloved by children from all over the world. Perched on a giant mushroom, Alice holds court alongside the Mad Hatter, the March Hare, the Cheshire Cat, the White Rabbit, Alice's cat Dinah and the bashful Dormouse.

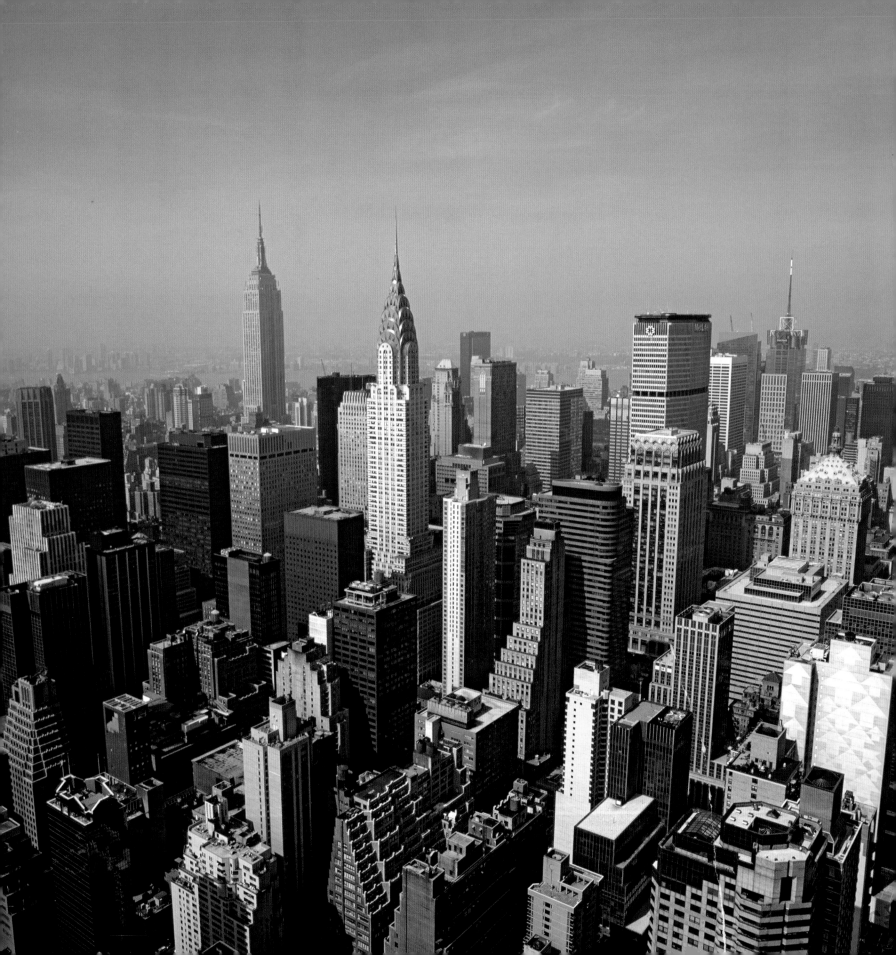